The Essence of

RED

The Essence of
RED

Belinda Recio

GIBBS·SMITH
P
PUBLISHER

SALT LAKE CITY

For my husband, Ed

ACKNOWLEDGMENTS

I would like to acknowledge the assistance of several people, beginning with my husband, Ed Blomquist, who assisted with research and contributed extensively to "The Rhythm of Red Music." Next is Mary Bemis, who also helped with research and consistently shared her ideas and editorial expertise. I am grateful, also, to the following friends for their contributions: Joan Wilcox for her editorial assistance; Lorraine Chernoff for her consultation regarding color analysis; Rebecca Donald for her gemological contributions; and Amy Buckley for her guidance on gardening. Finally, I would like to thank Cathy Kouts for her supportive encouragement throughout this project.

FIRST EDITION

99 98 97 96 5 4 3 2 1

Text copyright © 1996 by Belinda Recio
Image copyrights as noted on page 94.

This is a Peregrine Smith Book, published by
Gibbs Smith, Publisher, P.O. Box 667, Layton, UT 84041

Library of Congress Cataloging-in-Publication Data

Recio, Belinda, 1961-
The Essence of Red / written by Belinda Recio ;
edited by Catherine Kouts. — 1st ed.
p. cm.
ISBN 0-87905-738-6
1. Color. 2. Red. 3. Red in art. I. Kouts, Catherine.
II. Title.
QC495.R33 1996
155.9'1145—dc20 95-46325
 CIP

Printed in Hong Kong

Edited by Catherine Kouts and Dawn Valentine-Hadlock
Designed by Larry Lindahl
Cover photograph by Richard Kaylin/© Tony Stone Images

Contents

Red roses have long been
a symbol of romantic love.

THE
COLOR RED

A T THE TOP OF THE RAINBOW, WITH THE longest wavelength and the slowest vibration in the visible light spectrum, sits the strongest of all colors—red. Red is primary, aggressive, and intense. It borders infrared, that part of the larger electromagnetic spectrum that produces heat. So, when we say that red is hot, in a sense it is. Red is the color of fire and the sun. People tend to experience red rooms as being warmer than rooms of other colors. When young children were presented with wool mittens of assorted colors and asked to choose the warmest, most

selected red mittens. But red's not just about warmth—it's about power. Psychologically, red is the ruler of colors, claiming an authority with which no other color can compete. Throughout history, red has been the color of royalty and revolution, and it is the most widely used color in patriotic flags. Red commands our attention on stop signs, fire trucks, and warning labels. In Brazil, red cars are outlawed because of the high incidence of traffic accidents involving cars of this captivating color.

Seeing red quickens our pulses, pumps adrenalin into our bodies, and has the potential to make us stronger when these effects increase muscle strength. Red affects our eyes as well.

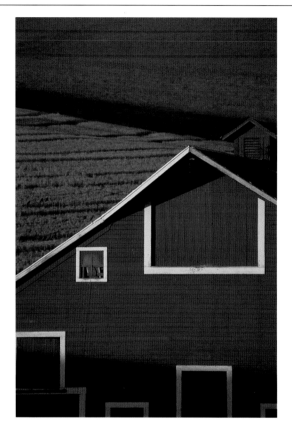

Barns are red, in part, because farmers found that this warm color was better at absorbing the sun's rays than other colors.

In order to see the color red, the lens of the eye has to make a special adjustment to focus on the red wavelength, and this focal adjustment makes red appear to advance or zoom in. When we feel an attraction to red— when a red dress beckons "come hither" or a red flower captures our attention in a garden— the attraction and magnetism of red is not merely psychological, it is physiological. It follows then that when our red hearts beat with the pulse of love or passion, we depict these feelings in shades of red.

Red is the most active of all colors— it's about creation and destruction, love and war, valentines and volcanoes. After black and white, red is the first color that babies recognize, and it's the last color we see at the closing of the day as we watch the sun set. The ancient cave paintings in Lascaux and Altamira are red, as is that ubiquitous icon of American culture—the

Coca-Cola can. Red is usually the first color to disappear from a child's crayon box and the last color emitted by a dying star. It is the color of fire, blood, roses for lovers, and the ruby slippers that returned Dorothy to the warmth of home and hearth.

As the poet William Butler Yeats claimed, "Red is the color of magic. . . ."

Jane's red dress beckons "come hither" and helps convey her outlaw sexuality.

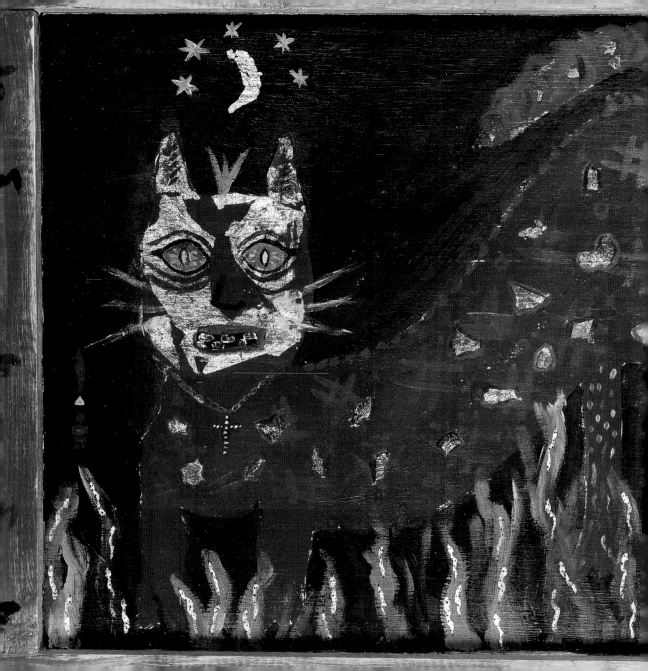

Women are often associated with
cats, and for artist Gayle Ray, a
"wild woman" is a red cat.

FEELING RED

The Psychology of Red

I F YOU'RE HAVING TROUBLE GETTING UP IN the morning, consider painting the walls of your bedroom red. Like the matador's cape, the red walls may inspire you to charge headfirst into the day. On the other hand, if you're married, the same red walls may incite you to charge at your spouse, so be sure to consider the risks as well as the benefits of red walls. The psychological effects of red range through a spectrum of what might seem like contradictory opposites—excitement, determination, and passion at one end, and frenzy, antagonism, and hate at the

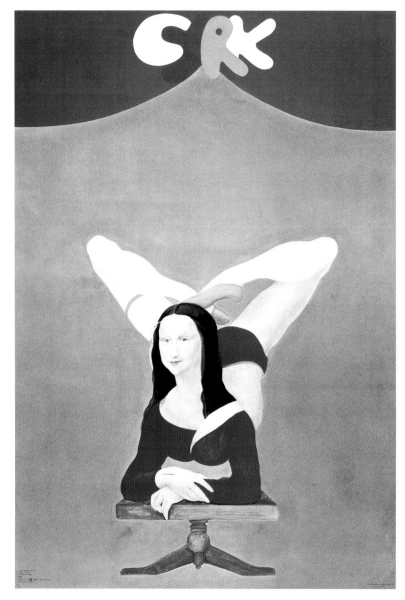

other end. The colloquial expression "seeing red" describes a state of anger so furious that all one can see is the taunting red flag of aggression. (The bullfight is, in fact, considered to be the origin of this expression.) The psychological association of red with anger is connected to the red blush of rage and the bloodshed of war.

At the other end of red's psychological range is excitement, particularly sexual. Red-light districts all over the world advertise the sale of sexual activity. Science has proven that the selection of red light for this purpose wasn't arbitrary. In one study, an Algerian scientist conducted an experiment with drakes, or male ducks, and prolonged exposure to red light. After 120 hours bathed in red light, the drakes'

This circus poster inverts the classic staid Mona Lisa into a fun and exciting acrobat clad in red.

testicles doubled in size and their sexual activity greatly increased. Somehow or another, the brothels of the world recognized the psycho-physical relationship between sexual energy and the color red long before there were scientific studies to substantiate it.

Red is a very physical color, and its psychological effects are not very different from its physiological effects. Red increases our appetites, adrenaline production, muscle strength, and blood pressure—it quite literally "revs" us up to "paint the town red." Red invites an attitude of reckless abandon that encourages living for the moment. Restaurant owners often exploit this fact by painting restaurant interiors

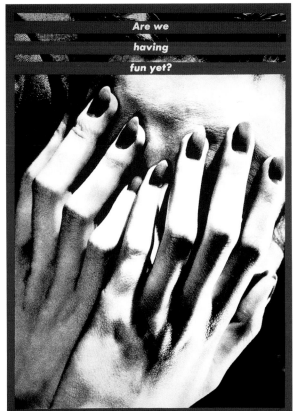

The symbolism of red has a wide-ranging dual nature, from rage to joy, and artist Barbara Kruger satirically sets them in opposition.

red, which not only increases appetites but also invites unchecked spending.

Red is associated with the expression of the life force—

the will to live, to love, to fight, to win. As such, red is strongly related to desire, whether that desire be to consume a five-course meal, win a game of tennis, or start a revolution. The color red is thus an invitation to action, the result of which can be positive or negative. Someone driven by ambition might live a life rich in the rewards of a successful career but lacking in the fulfillment provided by family and friends.

Although red is unquestionably an energizing color, there is one variation of red that produces results quite the contrary. Pink, which is a tint of red, has been proven to have a calming and sedative effect on many people. A California

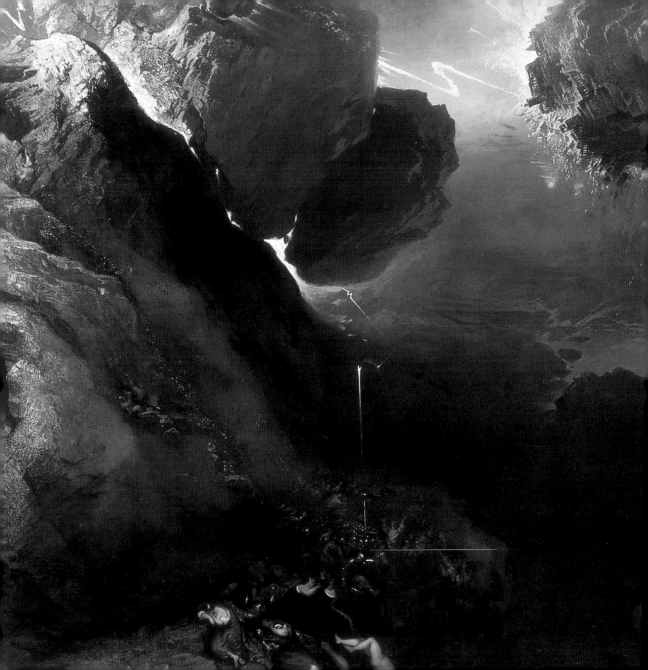

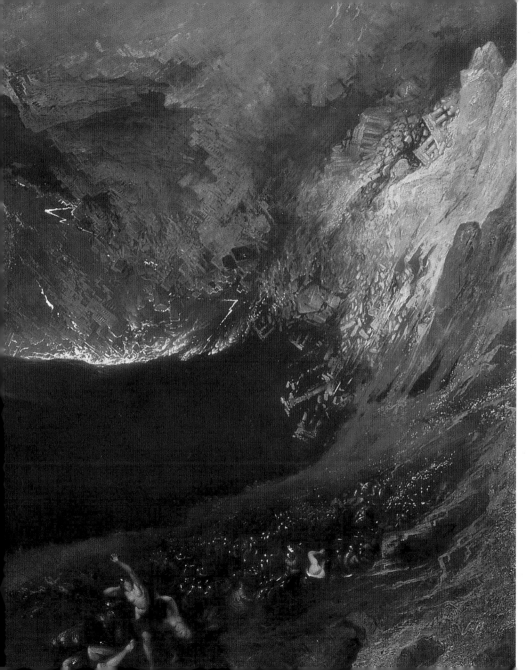

In *The Great Day of His Wrath*, God's fury is represented as a mass of swirling red anger.

Red in the Eye of the Beholder

THERE'S MORE TO SEEING RED than the metaphoric expression of anger. For us to experience the color red, light has to enter the eye through the cornea, travel through the pupil and lens, and form an image on the retina. The retina has three types of cones— red, green, and blue—whose spectral sensitivity results from pigment variations in each. The red cone is most sensitive to long wavelengths, the green cone to middle wavelengths, and the blue cone to short wavelengths. The red cone isn't the only cone to respond to long wavelengths; it is just the cone that responds best. The same is true for the green and blue cones responding respectively to middle and short wavelengths. We see color whenever these three cones are stimulated to different degrees. When all are stimulated equally, we see white. When the cones are stimulated in just the right proportions, they send a specific signal along the optic nerve to the brain, and we experience the color red.

children's probation department first tested the effects of "passive pink" on their physically violent inmates. Prior to the creation of the pink room—an eight-by-four-foot room with pink walls—children suffering from violent outbursts had to be physically restrained by guards. After the facility created the pink room, children suffering an episode of violent behavior were placed in the room. Within ten minutes the children relaxed, stopped screaming and thrashing, and sometimes even fell asleep. Although many psychologists remain skeptical of the effects of passive pink, there are an estimated 1,500 hospitals and correctional institutions in the United States that have a room painted passive pink. However, pink isn't limited to institutions; a few football coaches caught wind of pink's pacifying power and decided to paint their visiting teams' dressing rooms this calming color.

Vibrant red in a dream may foretell good fortune.

The Red Person

RED IS A STRONG, hot, passionate color, and most people who are attracted to red as a reflection of their inner selves possess the same characteristics attributed to this color. They are fiery and passionate with a lust for life. Because of red's stimulating properties, red people are often quick thinkers with great leadership potential. They are almost always extroverts who relish a challenge. The red person loves excitement, conquest, even danger. Think of the matador who faces the bull, waving the provocative red cape, or the female executive climbing the corporate ladder in a red power suit. Because red is a color associated with physicality, it may also express itself as athleticism or sensuousness. Red is traditionally the color associated with love and sexuality; thus the red person may be a very passionate lover. Perhaps the temptress in the red dress is no cliche after all.

Red people, despite their tendency toward emotional intensity, are also very receptive to external conditions and influences, and so they are usually sensitive to others' feelings. However, without self-restraint, red people quickly give voice to their sometimes scalding opinions without consideration for consequences. The drive of red, if unchecked, can lead to abrupt, impulsive, and reckless behaviors, such as aggression and hostility. Because the energy of red can be difficult to sustain, red people may find themselves periodically riding the "emotional roller coaster," with less-than-welcome effects on themselves and those around them. Red people may jump to conclusions, place blame on others, or be thrill-seeking hedonists. Tending to be quick on the trigger, red people may find themselves full of regret over their spontaneous behaviors. The negative side of the red personality reflects many of the cultural and symbolic images we ascribe to red—anger, war, violence, and revolution. Like a steam engine, the challenge of the red person is to keep a lid on the boiling furnace of red emotions while harnessing his or her incredible energy to do productive and inspiring work in the world.

Sometimes timid, introverted people feel instinctively drawn to red because this color represents the courage and confidence they lack. However, people for whom red holds no attraction may have cooler, more passive natures, and may

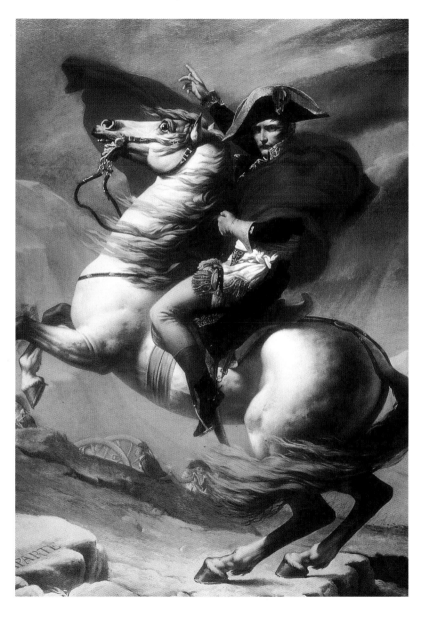

simply find red too intense as a result of their individual style. More dramatically, people who are repelled or disgusted by red may have suffered too much defeat in life.

Children love red; it is the color they choose most as their favorite. Researchers have demonstrated that red attracts the attention of toddlers and even preverbal infants to a greater degree than any other color. Because childhood is a time of tremendous physical growth, intense emotions, and seemingly boundless energy, it is not surprising that red would be particularly appealing to this age group.

Napoleon's personality was quintessentially red. He crowned himself emperor of France, conquered most of Europe, and was finally defeated as a result of his stubborn pride.

Dreams of Red

MOST PEOPLE spend one-third of their lives sleeping, and about a quarter of that time is spent dreaming. Therefore, psychology is concerned not only with our waking minds but with our dreaming minds as well. People have been interpreting dreams since the dawn of civilization. One of the first uses of written language is the recording of dreams, and there are records of dream interpretation that date back to over 3,000 B.C. As dreams were recorded and studied, people searched for clues to their meaning— for the "language" of dreams. Images and patterns were interpreted as symbols and signs, sometimes as part of a message from the gods, sometimes as omens, and more recently as a gateway to our subconscious.

Color is an important aspect of the language of dreams. Many psychologists believe that there is a strong relationship between the role of color in dreams and the emotions of the dreamer. There have been several studies that support the existence of a correlation between the saturation of color in dreams and the intensity of the dreamer's emotional life. Additionally, dreamers with detailed recollections of dream colors tend to have a deeper awareness of emotions in their waking lives.

SHADES OF MEANING

The meanings of dreams is still a mystery, predominantly because dream images are personal and the real clue to the meaning of a dream is always within the individual dreamer. Nonetheless, since the time of the ancient Babylonians, certain symbols have become associated with specific conditions and prophesies. When red is featured in your dream, the tint or shade is important as well as the forms in which it appears. For example:

A light tint of red, such as pink, suggests that you will experience the glory of success.

Hot reds, such as scarlet or vermilion, signify the stress of family quarrels.

Crimson hues foretell of happy news from a friend.

Red hair on a beautiful woman suggests that you will receive unexpected good news; red hair on children means that you will win a lottery.

The Wavelength of Energy: Healing with Red

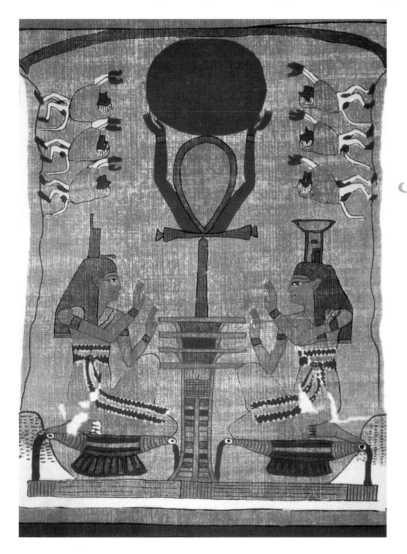

\mathcal{T}HE USE OF COLOR in the treatment of medical disorders goes all the way back to the ancient Egyptians. Archaeologists have discovered that ancient Egyptian temples contained rooms that acted as prisms, dividing sunlight into the colors of the spectrum. In their color therapy, the Egyptians used gems as well as solarized water, which is water infused with the wavelength of a specific color. This was accomplished by encasing a vessel of water in glass of the desired color and then placing

In ancient times, color therapy was practiced by the Egyptians as well as other civilizations.

it in direct sunlight for a prescribed time period.

In ancient times, color therapy was practiced by the Egyptians as well as other civilizations. However, with the maturation of civilization and the sciences in particular, the idea of color healing eventually became associated with quackery and deceit. Today, there are two different arenas in which color is used in a therapeutic capacity: traditional medicine and alternative medicine. The color red plays an important role in both.

For traditional, modern medicine, one of the events that changed the attitude toward the use of color and light for medicinal purposes was when, in 1903, Niels Finsen of Denmark won the Nobel Prize in physiology for the application of light in the treatment of skin diseases (including a form of tuberculosis). Since that time, modern medicine has come to accept the potential of color and light

Have a Glass of Red WATER *and Call Me in the Morning*

COLOR THERAPISTS SOMETIMES USE A WATER SOLARIZER to capture the energy of color in a glass of water. A water solarizer is simple to construct. To make a red-water solarizer, all you need are three panels of red glass, approximately six inches wide by ten inches tall (available from your local glass dealer or craft supply shop). Shape the three panels into a triangle and attach the edges with seams of two-inch-wide cellophane tape, like the type used to seal cartons. Put the solarizer in direct sunlight. Fill a clear glass with water and place it in the center of the solarizer for about an hour. (Note: if you can't find colored glass, you can try red cellophane attached to a cardboard frame.) Color therapists claim that the red energy may create a sour taste in the water, but then most medicine tastes unpleasant. The dose? Take a few sips every ten minutes. Although it might not taste or smell as good as coffee, according to some color therapists, the red water should increase your energy level and feelings of vitality.

in the treatment of a wide variety of disorders.

For years now, light just outside the visible spectrum such as infrared and ultraviolet has been used in modern medicine. Modern medicine acknowledges the physiological effects of red light—increasing blood pressure, stimulating appetite, and increasing hormonal and sexual activity. In the traditional medical community, some doctors have used red light to treat rheumatism.

Color therapy, a non-traditional approach to the use of color in medicine, is based on the premise that color is a product of light, and therefore it possesses energy in the form of vibrational frequencies. This color energy can be used to correct imbalances in the body and mind. Color therapy sessions generally involve treatment with colored lights;

however, colored baths, blankets, and even clothing can be a part of the therapy. Most color therapists claim that their treatment should be an adjunct to traditional medicine and not a replacement. Also, results are

gradual and gentle, so patience is required. Color therapists treat a variety of ailments with the color red. Because red increases blood pressure, low blood pressure is treated with exposure to red light. Other afflictions treated with red light include fatigue, depression, and, not surprisingly, impotence.

One aspect of Indian Ayurvedic medicine regards the body as being composed of *chakras*, or energy centers, each of which is associated with one color of the spectrum. The red chakra is considered to be the root chakra, energizing the feet, legs, tailbone, and sexual organs.

Red is symbolic of power,
strength, and the life force that
animates the physical world.

SEEING RED

Red Symbolism

EARLY 200,000 YEARS AGO, PREHISTORIC humans made paint from red ochre clay and used it to color their dead before burial. Even these early people knew that blood was essential to life; therefore, red—the color of blood—came to represent life and the qualities with which it is associated: action, strength, and vitality. The ritual of painting the deceased red before burial prepared them for the afterlife and the possibility of rebirth. In modern Japan, the color red plays the same role in the death ritual of Shintoism, in which a red cloth, representing blood—

the life force—is draped over a corpse to aid the departed in the afterlife.

When early humans saw that blood was spilled during battle, red also became a symbol for courage, aggression, and warfare. Through acts of assault and murder, the concept of crime was connected to red as well. Thus, when someone is apprehended in an act they should not have committed, they are said to be "caught red-handed," literally meaning that the proof of guilt is the red blood on the hand. Red also came to be associated with women and procreation because women bleed during childbirth and their fertility cycle. In many tribal cultures, this connection is echoed in the creation of red dolls and other amulets to increase female fertility.

Next to blood in the hierarchy of red symbolism is fire. Fire is beneficent, yet destructive. By associating red with fire, early civilizations reinforced many of the same symbols associated with blood —especially those related to life, death, and power. According to linguists and anthropologists, after black and white, red is *always* the first color word to develop in a language. The linguistic priority of red is a testament to its importance as a symbol for many of our most primal emotions and rites of passage. All color symbolism is somewhat ambiguous, and the symbolism of red is no exception. However, of all color symbolism, red symbolism demonstrates the greatest consistency across cultures and throughout history, and many of the basic associations made by humans 200,000 years ago have survived into the present.

RELIGION

In most religions, red is primarily the color of love, sacrifice, and sin. This is true for both Judaism and Christianity; however, for Christians, red specifically represents the blood

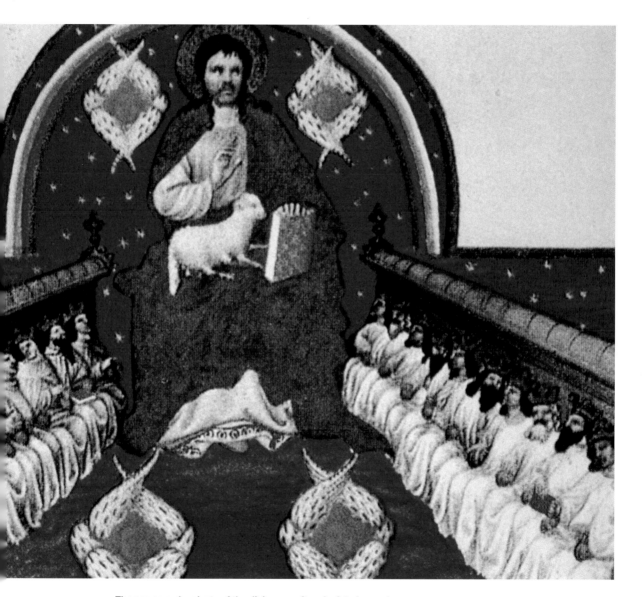

The power and majesty of the divine are often depicted as red.

of Christ and martyrdom, reflected in the ecclesiastical attire of cardinals, bishops, and the pope. In the Christian trinity of Father, Son, and Holy Ghost, the Holy Ghost is represented by red. At Pentecost, red symbolizes the receiving of the Holy Ghost during communion. In Christian visionary experience, the color red is related to both glory and sin.

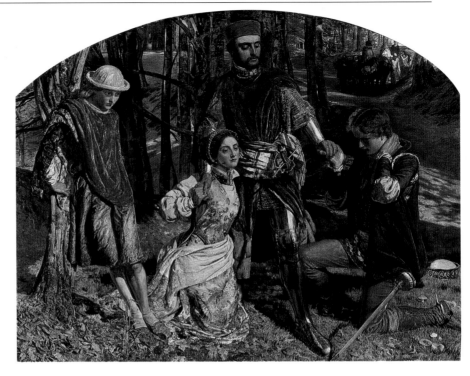

The brilliant reds in *Valentine Rescuing Sylvia from Proteus* contribute greatly to William Holman Hunt's painting inspired by Shakespeare's *Two Gentlemen of Verona*—a play about love and violence.

THE COLOR OF LOVE

Proof of love's crimson hue is everywhere, beginning with the rhythm of our red hearts. Passion could be no other color; it is all-consuming, like fire in the wind. When we're young and in love, we blush a rosy red. Later, adult desire can conjure the color red from deep inside our bodies, creating the crimson blush of physical ecstasy. In many Eastern philosophic traditions, the root *chakra* at the bottom of the spine is red, symbolizing, among other things, the sexual energy that accompanies passionate love.

Physically and symbolically, red is the color of love. We honor the ideal of romantic love through the very red celebration of Valentine's Day. We exchange red valentines, packages wrapped in red paper and ribbons, and red heart-shaped

boxes of chocolate. However, the Valentine gift presented far more than all the others is the red rose—one of the oldest symbols of love. In the United States alone, nearly a billion red roses are purchased on Valentine's Day.

Valentine's Day has a colorful and somewhat confusing origin. Popular legend recounts that a third-century priest named Valentine was the first to send a "valentine." During the reign of the Roman Emperor Claudius, single men were in great demand to staff the emperor's army. To ensure a steady supply of soldiers, Claudius outlawed marriage for a time. However, Valentine, ever in the service of Cupid, married young couples despite the emperor's decree. For his sentimental stand, Valentine was sentenced to death. On the day of his execution, February 14, Valentine sent the jailer's daughter—with whom he had fallen in love—an affectionate letter signed "Your Valentine."

Later, in A.D. 496, Pope Gelasius declared that February 14 be commemorated as Saint Valentine's Day.

As romantic a legend as it is, some historians claim that there is no true connection between Saint Valentine and the holiday, but believe instead that this lover's holiday is connected with the mating season of birds. Other scholars assert that, like many contemporary holidays, Saint Valentine's Day is based on an earlier pagan celebration, in this case an ancient Roman festival called "Lupercalia." Lupercalia was essentially a fertility rite in which men ran through the streets lashing women with strips of goat leather, called *februa*. The lashing itself was called *februatio.* The name of the festival no doubt relates to *lupus,* meaning wolf, and because the wolf was sacred to Mars, the Roman god of war, historians speculate that it was Mars who presided over this festival. Mars was a god

strongly associated with the color red and with attributes such as aggression, vitality, and sexual drive. While it seems clear that the month of February was named after the *februa,* the origin of Valentine's Day, like the origins of many holidays, is probably a combination of observations of nature, borrowed rituals, and romantic legend.

Will You Take This Woman in Red?

Brides may wear white in many Western cultures, but other cultures celebrate the ritualized union of man and woman with the passion of red. In China, a "scarlet woman" doesn't wear the shameful letter of adultery or practice promiscuity, but instead wears the deep scarlet hue of love on her wedding day. The traditional Chinese wedding, like the celebration surrounding the new year, is a parade of red. The bride wears a red dress embroidered

with dragons and carries a red parasol. She is carried to the home of her new groom in a red sedan chair (today, many families use a red automobile for this purpose) decorated with lanterns that bear the name of the groom's family in red. Red fireworks set the sky ablaze, and the bride and groom drink from two cups bound together by a red cord.

The wedding gifts are wrapped in red, symbolizing fertility, life, and happiness. Pomegranates were often given as wedding gifts, representing wishes for many children. Many Hindu brides also wear traditional red attire, and after the wedding, Hindu wives wear a red mark on their foreheads until their husbands die. After each verse of the Hindu wedding blessing is sung, guests shower the bridal couple with rice grains colored red by kum-kum powder.

SEX AND THE SCARLET WOMAN

If love is red, then sex is that fiery chroma of red called scarlet. Red resonates deeply with symbolism associated with sex, and many of these symbols center around women, who for biological as well as other reasons, have a uniquely intimate relationship with the color red. Since ancient times, women have used red in their rituals of beauty—painting lips, cheeks, and nails various shades of red. Hindus recognize red as the sacred color of Lakshmi, the Indian goddess of beauty

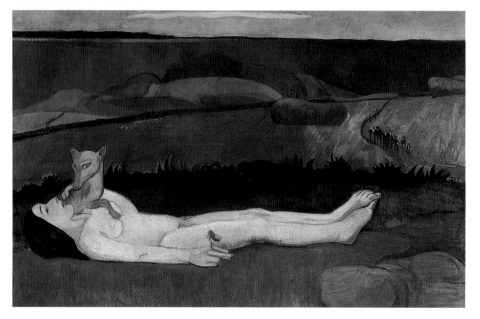

Red resonates deeply with symbolism associated with sex. In Gauguin's *The Loss of Virginity*, the red hills and seductive red fox are evocative of the woman's entry into sexuality.

and pleasure. But even though red beauty rituals have existed since 3,000 B.C., the connection between women and the color red is more than just skin deep.

According to legend, Adam's first wife was Lillith, a red-haired woman created by God from the earth, as was Adam, and not from his rib, as was Eve. Lillith was expelled from the Garden of Eden for her failure to comply with the dictates of God regarding the missionary position of sexual intercourse, and her predilection for preferring the company of demons to that of her more conservative husband. After expulsion from Eden, Lillith became Satan's favorite bride, mothering the Succubae, the female sex demons who tormented monks in their sleep. The color of Lillith's hair is an important symbol in this story because, since biblical times, red hair has been (unfairly) associated with lewdness, betrayal, and tempestuous natures.

In the Bible's Book of Revelation, St. John's vision of a whore adorned in scarlet sitting upon a scarlet-colored beast established a powerful sexual association between women and the color red. Unfortunately, his vision also supported the association between women and sin. Although biblical scholars believe that the scarlet woman in St. John's vision represented the ancient pagan city of Rome—because it had the blood of Christian saints on its hands—the connection between women, sex, and the color red continued.

In Puritan New England (as well as in Nathaniel Hawthorne's famous novel), a scarlet letter "A" for "adulteress" was sewn onto the dresses of women convicted of adultery. In *Gone with the Wind*, Scarlett's name serves as an echo of her unfaithful behavior. The use of red to signify sex still exists in the red-light prostitution districts of cities.

Another "scarlet woman" is Little Red Riding Hood. Although this classic fairy tale has existed in a variety of forms for hundreds of years, it wasn't until recently that the image of Little Red Riding Hood has been transformed into an icon of the temptress in red. Little Red Riding Hood has appeared in numerous advertisements, selling products through her seductive appeal.

In a 1962 print advertisement for Hertz Rent A Car, a not so little Red Riding Hood is on the road (in a Hertz car, of course) to grandmother's house. The visual subtext suggests that anything might happen along the way. In advertisements such as this one, Red Riding Hood is playing the classic scarlet woman— a temptress promising sexual promiscuity. In an advertisement for Johnny Walker's red label scotch, Little Red Riding Hood's traditionally scarlet garb has been bleached white; consequently the wolf is walking

away, disinterested. The accompanying slogan reads: *"Sans le Rouge rien ne va plus"* ("Without Red, nothing will work"). The sexual connotations of the color red couldn't be better exploited; the message is clear: you need the color red to capture the wolf's interest. Many folklorists and psycho-analysts have suggested that the story of Little Red Riding Hood is a cautionary tale about the dangers of temptation. Red Riding Hood strayed off the safe path of morality and fell into the trap of the wolf because she gave in to her temptation to talk to strangers. Throughout history there have been many different versions of this tale, and in nearly all of them, the little girl is dressed in red—the color of sin. Another less recognized con-nection to red is through the wolf, who is the sacred animal of Mars, the red god known for, among other attributes, his sexual drive.

Many folklorists and psychoanalysts have suggested that the story of Little Red Riding Hood is a cautionary tale about the dangers of temptation.

THE POWER OF RED

The color red not only dominates the domains of love and sex, it also rules the realm of royalty. In Britain, red is truly king—and queen. The royal family and imperial power are represented by the crimson of the monarch's robes and the bright red blazers of the soldiers stationed outside Buckingham Palace, where the famous "Changing of the Guard" is a major tourist attraction. At the opening of Parliament, the pomp and circumstance is attended by the monarch draped in a red robe forming a red train, bishops wearing red ecclesiastical robes, military personnel and nobles smartly outfitted in red uniforms, and High Court judges swathed in dignified red academic gowns.

THE COLOR OF HAPPINESS AND LUCK

Because red is a symbol of life and vitality, it is often regarded as a fortuitous color. The Chinese regard red as a lucky color representing joy and abundance. Consequently,

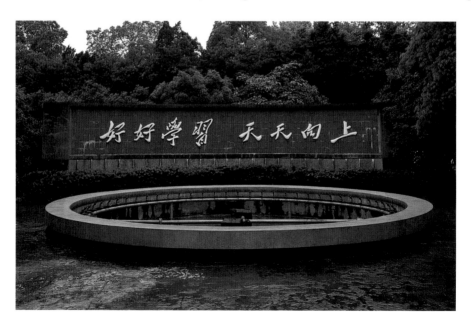

This public message translates as "Study Diligently and Improve Yourself Daily"—good advice for a life filled with happiness, with which red is associated in China.

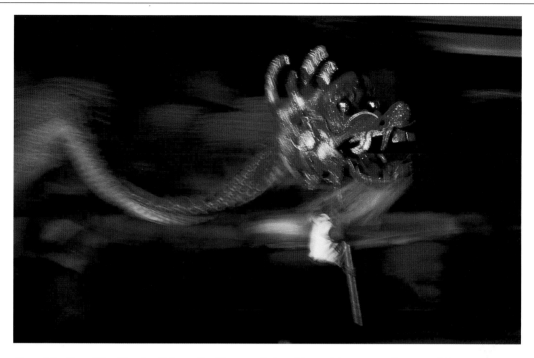

The celebration of Yuan Tan, the Chinese New Year, concludes with a red dragon parading up and down the street.

red is featured predominantly every winter at the lunar new year, when the calendar changes from one animal ruler to the next. At that time, Chinese people throughout the world celebrate Yuan Tan, the Chinese New Year. This joyous occasion includes the display of many festive decorations—banners, lanterns, lights, and candles—most of which are red. The Chinese New Year also features red foods such as the pomegranate with its multitude of deep red seeds, which traditionally signified wishes for the good luck that many children bring. On the last night of the festival, a dragon with a red velvet train parades up and down the streets, signaling the end of the fourteen-day celebration.

The Chinese aren't the only people who recognize red as a symbol of happiness. In the intricate patterns of Persian carpets, red symbolizes good fortune and joy; Egyptians started the tradition of using red ink for recording important events as well as happy dreams;

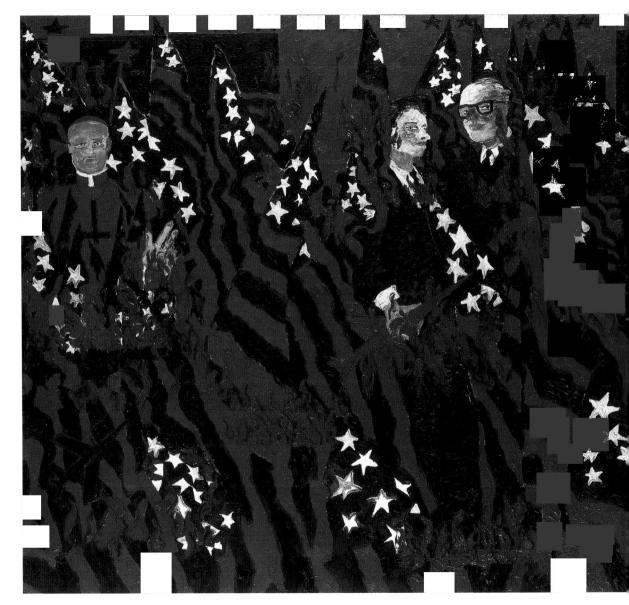

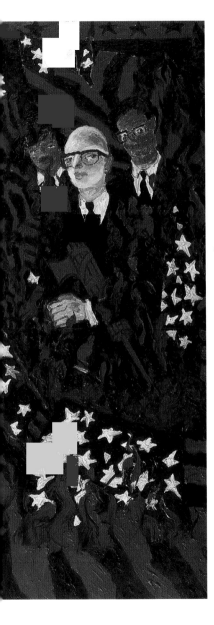

and the Catholic Church followed suit by marking feasts and saints' days in red. Therefore, in colloquial language, a happy day worth remembering is called a "red-letter day."

THE DARKER SHADES OF RED

Throughout history, red flags have been battle symbols, red uniforms and ribbons were the insignia of revolutionaries, and the painful red badge of courage—a metaphor for a bloody war wound—has been worn by millions of soldiers. The color red represents these dark images of fury, violence, war, and bloodshed.

Not as devastating as warfare, but nonetheless representative of violence, is the dramatic and bloody ritual known as the *corrida de toros*—running of the bulls—more commonly

Red is often used as a color symbolic of patriotism, tinted with irony in Derek Boshier's *False Patriots*.

known as a bullfight. The bullfight dates back over 2,000 years to Roman times. In this strange and dangerous spectacle, the matador wields a red cape, the *muleta*, with which he (or occasionally, she) taunts the bull. Interestingly, bulls are actually color blind, so they can't see the redness of the cape. However, the red color of the cape heightens the drama for the audience and represents the danger that the matador faces.

Also associated with danger are the symbols of warning with which red is connected. Red lights and stop signs, poison and hazard symbols, exit signs, brake lights, and countless other red-colored objects demand our attention. A red alert is a situation of extreme urgency. The United States employs a color safety code that uses red to designate all equipment related to fire protection and fire fighting: alarms, hydrants, sprinklers, hoses, and fire trucks.

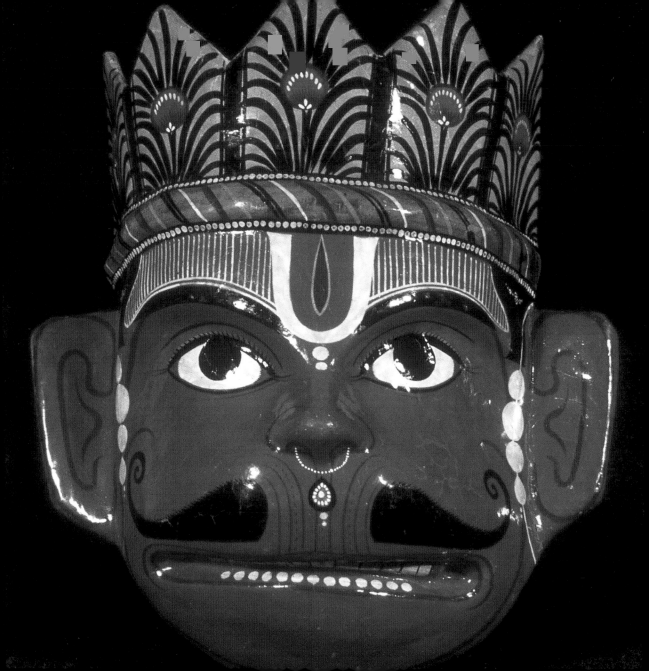

Red Deities, Legends, and Mythologies

THE RED FACE OF DIONYSUS

MANY GODS, GODDESSES, and figures from folklore are colored red. On the "scarlet" side of red, there's Dionysus, also known as Bacchus, god of nature, wine, music, and poetry. Dionysus is considered a symbol of the frenzied unleashing of desire. Carl Jung, the Swiss psychoanalyst, saw Dionysus as a representation of emotion carried to the extreme. Dionysus was frequently depicted with a deep red face, probably due to all the drinking and sexual

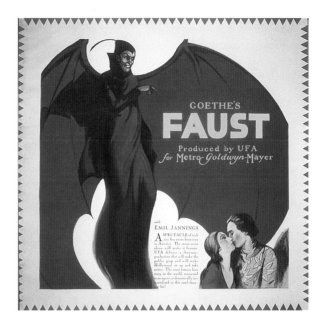

GOETHE'S
FAUST
Produced by UFA
for Metro-Goldwyn-Mayer

EMIL JANNINGS

Opposite: **Hanuman, the Hindu monkey god, is traditionally depicted with a red face. He is considered a beneficent guardian spirit.** *Above:* **Faust, a sixteenth-century German magician, is known in legend as the man who sold his soul to the Devil for knowledge and power.**

cavorting during the bacchanalian festivals held in his honor. From these festivals comes the term "Dionysian," an adjective for wild, uninhibited, orgiastic activity. These festivals may be the origin of the expression "to paint the town red," meaning to have a riotously wild time, usually involving the consumption of alcohol and behavior associated with loose morality.

THE DEVIL AND OTHER RED DEMONS

The ultimate evil figure in the Judeo-Christian tradition is the Devil, who, as the embodiment of evil, also appears in other guises in most of the world's religions. Before the Devil was cast out of heaven for the sin of pride, he was Lucifer, bearer of light. After expulsion from

heaven, he became Satan, which is the Hebrew word for "adversary." Satan, who rules the fiery infernos of hell, is frequently depicted as red in color. The perennial Halloween costume of the Devil includes a red cape, mask with horns, and a red pitchfork. There are many superstitions connecting the Prince of Darkness to the color red. For example, in Ireland if a guest attends a wedding concealing a red handkerchief tied in knots, the Devil will curse the newlyweds.

In addition to Satan, there are many red malevolent beings from around the world, including the blood-smeared Riri Yakka, the Sri Lankan Demon of Blood. Riri Yakka is one of the horrifying demons sought to be exorcised by the "devil dance," in which the male dancers wear red cloths around their heads. There is a bloodthirsty South Indian deity

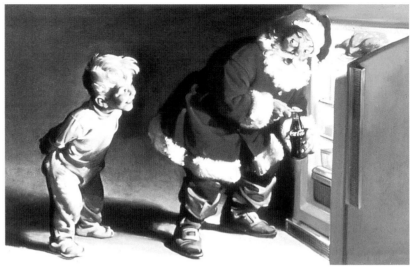

Santa's red attire and the Coca-Cola logo are two of the more popular red icons of American culture.

called "Chokannatadi" or "Red Beard"; and Kali, the Hindu goddess of death, is sometimes depicted as being red in color—the result of being smeared with blood.

SANTA'S RED SUIT AND RUDOLF'S NOSE

Red isn't just the color of devils and demons; it is also the preferred hue of benevolent characters from folklore and

mythology. Best known to Christian children is the character of Santa Claus.

The real Santa Claus was Saint Nicholas, a bishop born in the fourth century, known for his generosity with the poor and his affection for children. He became the patron saint of Russia, Greece, and Sicily, and is believed to have died on December 6. The very first legendary Saint Nicholas carried a crooked crosier (a staff

resembling a shepherd's crook), was assisted by a donkey, and wore the red robes of a bishop to honor his namesake. However, the Santa best known to most Americans was the product of Dr. Clement Clark Moore's poem, "The Night Before Christmas," and the illustrations that brought Moore's character to life. Over time, through illustrations published in *Harpers Weekly*, Santa Claus put on weight and grew less elegant and more elfish in appearance. However, the red suit remained as a symbol of the love and martyrdom that red represents in the Christian faith.

Not to be forgotten in the contemporary Christmas tradition is Rudolf the Red-Nosed Reindeer, considered by folklorists to be the only twentieth-century addition to the Santa Claus legend. The red color of Rudolf's nose may be merely a matter of practicality, for just as the red beacon of a lighthouse guides ships to shore in bad weather, Rudolf's red nose was the perfect headlight for a sleigh team that traveled in winter.

REDCAPS

The folklore surrounding fairies, elves, goblins, and trolls reveals that red is often the preferred color of mythological creatures. The Irish poet William Butler Yeats pointed out that red is strongly associated with folklore and with magic in general. One of the most interesting races of "little people" are the Klabautermannikins and Kaboutermannikins, the mythological creatures that populate the folk tales of the Dutch, Belgians, and Germans. The Klabautermannikins were said to be protective spirits living in the figureheads of ships, which were ideally carved from trees believed to contain the souls of dead children. The Kaboutermannikins were Klabautermannikins who had taken up residence on land, often in caves or castles. While the Klabautermannikins were seen to be friendly and benevolent, the Kaboutermannikins often had a dual nature, being sometimes very helpful with household chores and other times lazy, mischievous, or greedy. Both Klabautermannikins and Kaboutermannikins were reported to wear tight red jackets and tall red hats.

Folklorists believe that the Kaboutermannikins may have "immigrated" to the British Isles because there the term "redcap" is a generic term for fairies as well as a specific term for a usually evil fairy that haunted the towers along the Scottish borders. The evil redcaps wore caps dyed red by blood. Providing you could quote the Bible, you could ward them off with holy words. Just as the Kaboutermannikins had a versatile nature, not all redcaps were evil; some were regarded as lucky.

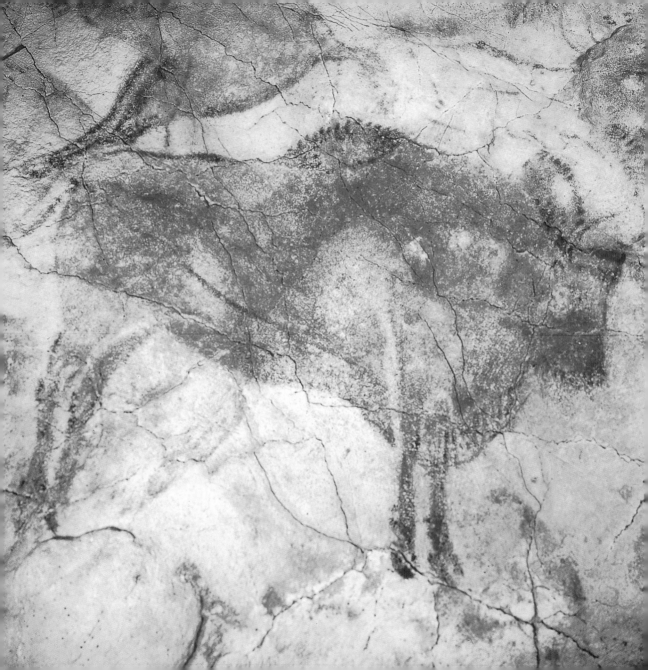

Prehistoric art, like this bison from the Altamira caves in Spain, was often created with red pigments.

CREATING RED

From Cave Paintings to "The Red Couch": A Red Retrospective

F ROM THE RED OCHRE OF PREHISTORIC CAVE paintings to the famous red couch that traveled 100,000 miles throughout America, the color red has provided a distinctive chromatic voice with which the human spirit has often spoken. This ancient color has served artists throughout history as a symbol for life's most intense experiences and extremes, such as death, magic, and passion. Because red advances toward the eye, it makes a statement in any environment. In the photographic project "The Red Couch," the color red was a motivating factor without which

the project may not have happened. For abstract expressionist Barnett Newmann, red evoked primeval associations that were at the heart of many of his compositions. The pulsing, vibrant character of the color red has inspired a wide variety of art throughout history, selected examples of which are presented in this section.

Prehistoric Cave Paintings

Some of the earliest art created by humans is the cave art in Altamira, Spain, and Lascaux, France. The paintings discovered in these locations have a palette limited to a few mineral colors, usually dominated by red ochre. The cave paintings in Altamira date back to the end of the paleolithic era, approximately 15,000 years ago. The large renderings of animals and hunters are painted in red and brown ochre. As ancient as the Altamira paintings are, the prehistoric cave art in Lascaux, France, is thought to be twice as old—dating back to 30,000 years ago. As in the caves at Altamira, the paintings in Lascaux are primarily images of animals—bulls, horses, deer, and wild cats—colored in red and outlined in black. Some archaeologists believe that in prehistoric art the color red symbolized life, just as it had in the burial rituals. It has also been suggested that early humans may have believed that the act of painting the animals' images would ensure a successful hunt.

Greek Red-Figure Pottery

During the sixth and fifth centuries B.C., a distinctive red-and-black pottery was produced in Athens, Greece. Known as Attic red-figure pottery, the new style reversed what had been the traditional style of pottery, which was called black-figure pottery. In black-figure pottery the Greeks painted figures with black glaze on the red clay background. In the new red-figure pottery, however, the artisans applied the black glaze as a background color, leaving the red clay to show through as the lines and forms that created the images. This innovation may have been inspired by architectural relief sculptures that presented light figures raised against a dark background. The new red-figure style was striking because the designs that decorated the pottery—images from mythology as well as daily life—looked almost three-dimensional, partially as a result of red's tendency to advance toward the observer. Attic red-figure pottery is valued today for its simple beauty and economy of color.

This reddish color connotes the warmth and comfort that enfolds this sleeping Persian youth.

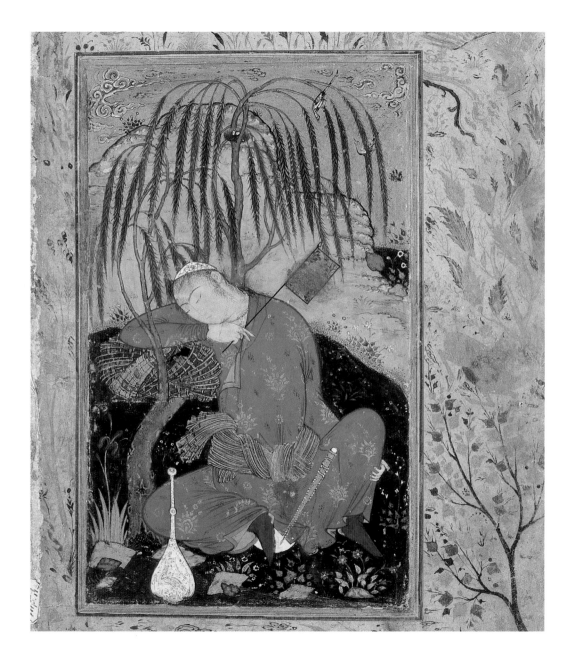

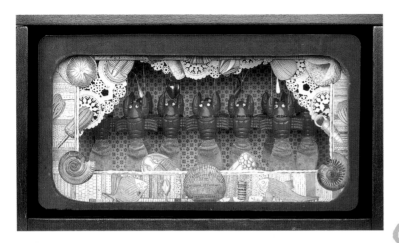

The dancing red lobsters along with the red border contribute to the visual whimsy of this assemblage by Joseph Cornell.

from such diverse sources as television advertisements, political campaigns, and the space program, all the while retaining the bright red hue as the base color from which the wild designs spring.

EDVARD MUNCH'S PULSATING REDS

Edvard Munch (1863–1944), a Norwegian painter and printmaker, was a major influence on the German expressionist movement in the early 1900s. As an artist, Munch was concerned primarily with inner visions, dreams, emotions, and sensations rather than with the observation and depiction of nature. To express these abstract states of consciousness, Munch relied on the symbolic

THE MOLAS OF THE CUNA

The Cuna, an indigenous people of Panama, practice a unique traditional art form, the appliqued blouses known as *molas*. Most mola blouses feature red as the primary color and are ablaze with a menagerie of images. The sewing of molas evolved from an earlier custom of painting directly on the body, which had existed prior to Cuna contact with European explorers and settlers. As Christian missionaries brought clothing to the Cuna, the women began to add bands of bright red to their clothes, which over time evolved into the brightly colored designs for which the molas are famous today. Incorporating elements of the Cuna folk art such as animal and plant motifs, the mola as an art form has continued to develop in response to the modern, technological world, appropriating images

"I tried to express, through green and red, the terrible passions of humanity." —Vincent van Gogh, on his piece entitled *Night Cafe*. Van Gogh's paintings demonstrate, among other things, the emotional intensity that accompanies color.

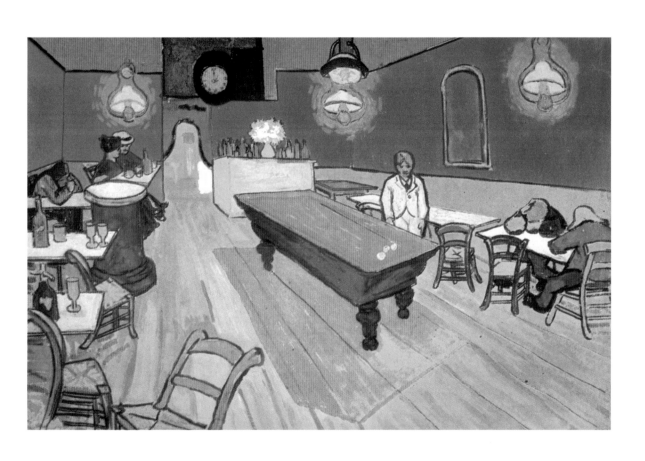

and emotional content of color as well as its optical effects. He is best known for his painting *The Scream*, which epitomized the profound angst and spiritual malaise prevalent in turn-of-the-century Europe. *The Scream* is a painting of a nightmarish hallucination Munch had while walking at sunset. In his hallucination, the clouds turned blood red and nature seemed involved in a conspiracy of terror. The swirling red lines in the sky are echoed in the linear streaks of blood red along the walkway in the painting. The optical tendency of red to advance, combined with Munch's shock waves of pulsating color, create a dizzying sensation of movement toward the viewer.

In *The Dance of Life*, another Munch painting, youth and innocence are represented by a woman in white; age and

Robert Motherwell, like many abstract expressionists, often emphasized color in his work.

wisdom are represented by a woman in black; and the life force is represented by a woman in a red dress dancing with a man. Her dress seems to spill onto the floor and envelop her dancing partner in an aura echoed in the red outlines surrounding the other figures in the painting. In another painting, *Separation*, Munch uses a flaming red bush to represent a heart ravaged by anguish. In many of Munch's paintings, red's vibrant intensity is rivaled only by the emotional content it represents.

ABSTRACT EXPRESSIONISM & COLOR-FIELD PAINTING

Abstract expressionism was an American art movement of the 1940s and 1950s, which grew out of the New York School of painting. In the early days, abstract expressionism had two broad directions: the "gestural" and the "color-field" painters. The gestural painters abandoned most of the inherited

classical techniques of painting and instead relied on non-traditional methods to achieve a nonrepresentative, organic quality in their art. The color-field painters were generally more restrained, producing canvasses on which sheets of color seemed to hover, collide, and flow into, across, and through each other. One of the most radical color-field painters was Barnett Newman (1905–1970), who, through an extreme simplification of form and emphasis on color, sought the expression of an "original chromatic force" capable of evoking the infinite and the sublime.

In Newman's *Onement I*, a canvas covered with dark red paint is interrupted only by a single orange line running vertically through the center of the painting. This dividing line has been interpreted as a reference to creation, and the red field as a representation of chaos. The content of Newman's art was undoubtedly

influenced by his interest in ancient mysticism. The imagery in his work has been compared to the moment in the drama of the creation myth when God interrupts space—Chaos—to manifest himself. In a later painting, *Vir Heroicus Sublimus*, a large red expanse achieves a sublime status, while vertical lines appear as statements of presence. Newman, like many other abstract artists, pursued an abstract symbolic language through color and relied on the color red for its powerful chromatic essence and archetypal associations.

CONCEPTUAL ART AND "THE RED COUCH"

Conceptual art, with its focus on the artist's idea as opposed to the artifact, had its roots in the creative ferment of the 1960s and early 1970s. The viewer of conceptual art usually experiences the "concept" through its documentation via videography or photography, which frequently contributes additional dimensions to the work because these mediums (videography and photography) are art forms in and of themselves. As such, many conceptual art projects can be difficult to categorize because they fall within more than one category of art, as in the photographic conceptual art project called "The Red Couch."

For four years, photographers Kevin Clarke and Horst Wackerbarth moved and photographed an eight-foot-long, 200-pound, red velvet couch across twenty-six states. Although the photography was of paramount importance to the project, the concept of the red couch traveling across America was just as significant. The couch traveled 100,000 miles by dog sled, helicopter, canoe, ski lift, automobile, and several other methods. When the red couch wasn't on the go, it sat atop a merry-go-round, floated on a lobster boat, and occupied floor space in the middle of the New York Stock Exchange. The red couch seated the rich and famous, the poor and homeless, members of the Hell's Angels, Daughters of the American Revolution, and hundreds of other people as well as several animals. The red couch served as the focal point for a series of photographs that became a documentary portrait of American culture. Without the red couch, the photographs would have appeared mundane and disconnected; with the red couch linking together the disparate subjects, the photographs became part of a larger statement. Clarke claimed that the red color of the couch was an important part of the project, and he hypothesized that the project would never have happened if the couch had been a different color.

In this dramatic tattoo, Kintaro, a hero of Japanese folklore, wrestles a giant carp surrounded by maple leaves.

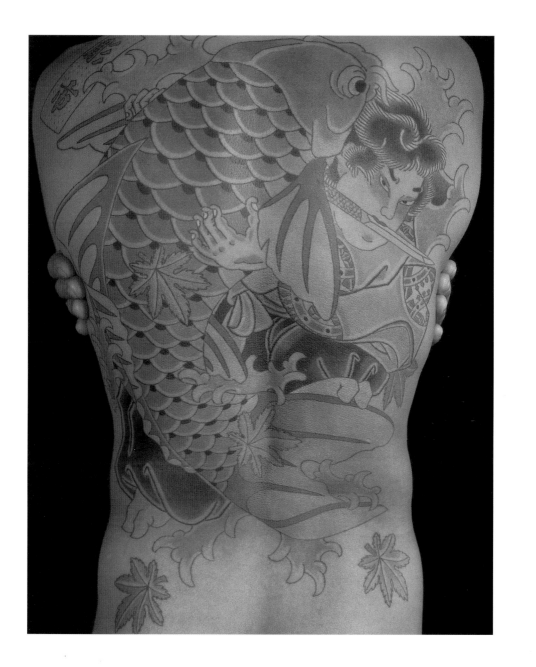

Red Architecture

C OLOR HAS ALWAYS been one of the fundamental concerns of the architect. In early civilizations, the coloring of architecture was strongly influenced by the symbolic codes of religion and other cultural institutions. As the color most associated with power and strength, red has often been used in the coloration of structures that housed the powerful. In Beijing, the Chinese emperors, together with their wives, concubines, and eunuchs, lived sumptuous lives, secluded from the common people, behind the dark red walls of the Forbidden City. During the Pentecost and Feasts of the Holy Cross, many churches "dress" in red through the display of red altar cloths and vestments of the clergy. The stained-glass windows of many churches and cathedrals feature red as a prominent color, sometimes as a background color in portraits of kings and apostles. Red is also the color of grandeur, which is why theaters traditionally had red velvet curtains and plush red seats. Today, color is still used symbolically. Fire stations are often built of red bricks or are painted red to symbolize danger as well as fire itself. Since antiquity, people have known that wine can cause a blush to color the faces of those who drink it; consequently, the interiors of bars are often painted red as a reflection of the spirit of indulgence. Hospitals and other medical facilities frequently use the symbol of

Designed in the 1920s as a larger replica of the vault in the Imperial Throne Room in Beijing's Forbidden City, the Fifth Avenue Theater in Seattle is expressive of all the grandeur associated with red.

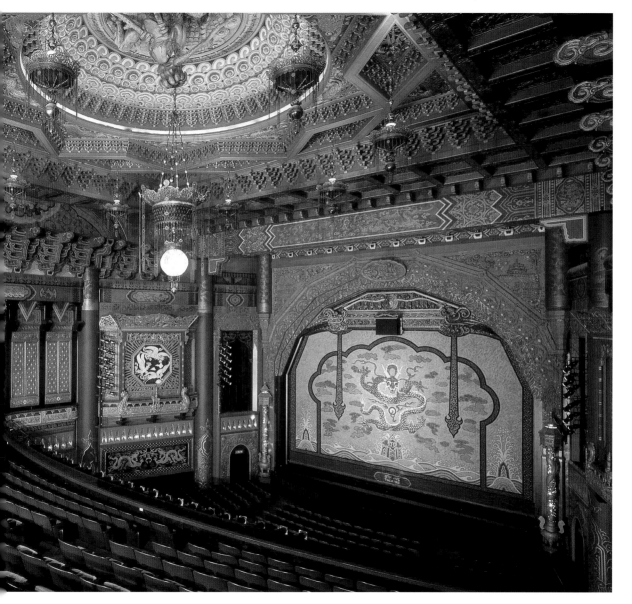

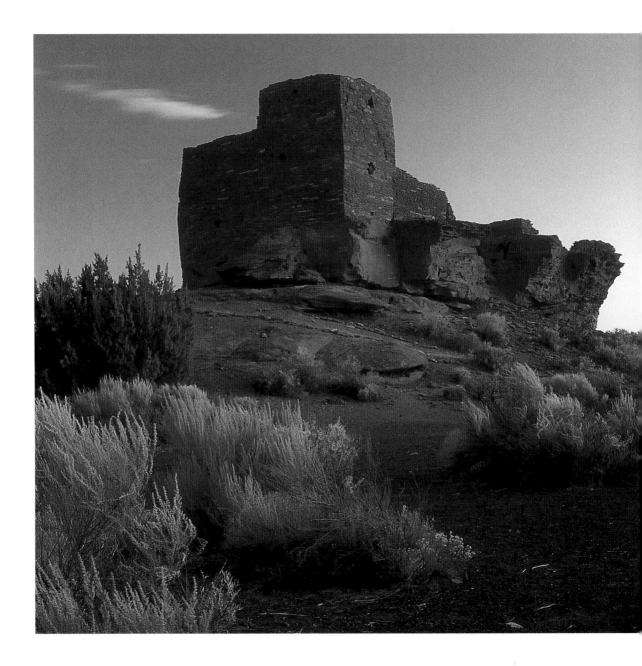

the red cross to communicate their commitment to healing the sick and wounded.

As architecture evolved, the intimate connection between color and religious symbolism gradually gave way to more secular and aesthetic concerns. Color was primarily used to establish unity or diversity with the surrounding environment—to create atmosphere, define form, and manipulate proportion, scale, and weight. The color red, often used to attract attention, is a natural choice for architectural diversity. Britain's "Red House," designed for artist William Morris by architect Phillip Webb in 1858, is constructed of orange-red bricks, topped by a dramatic red-tiled roof, and surrounded by a red-brick wall. The color of Red House boldly distinguishes it from the surrounding natural and architectural landscapes.

The abundance of red rock in the southwestern U.S. resulted in the reddish dwellings of the Anasazi.

Architectural color is sometimes the result of pigment and material availability. The abundance of red rock in the southwestern United States resulted in the red masonry dwellings of Native American tribes such as the Anasazi. Even today, indigenous red clay is used in contemporary adobe dwellings. The red color of the classic barn of the New England landscape was also the result of material availability. Farmers needed a way to preserve their barns, and an inventory of local materials yielded plenty of red iron oxide, milk, and lime. These became the ingredients of a durable coating that withstood the harsh New England weather and established the tradition of red barns. As an added advantage, red barns were warmer in the winter because the color red absorbs more of the sun's rays than many other colors. It is likely that the "little red schoolhouses" of early America were painted red for similar reasons. Farther

south, in Pennsylvania, red
clay was plentiful; therefore,
the Pennsylvania Dutch farmers
colored their landscape with
red barns, red bricks, and red
folk art.

The color red is not limited
to architectural exteriors; red
has also been used as an interior
color throughout a variety of
period styles, ranging from
the sensuous Pompeii red of
the Renaissance and the rich
crimsons of the Baroque period
to softer tints, such as Rose
Pompadour, popular during
the reign of France's Louis IV.
The Georgian period saw a
return of rich warm reds such
as those of Chippendale's
polished mahogany furniture.

DECORATING WITH RED

Because red is evocative of
luxury and excitement, it is a
good color for rooms intended
for socializing, such as dining
rooms or living rooms. Today,
every imaginable tint and
shade of red is available, from

the deepest burgundy to the softest coral. However, if the idea of an all-red room seems overwhelming, consider using red as an accent. In combination with white, red evokes hospitality and informality, perfectly represented by a checkered tablecloth. Strong cool reds, such as crimson, combined with forest green—its complementary color—create a dramatic effect. When warm reds, such as scarlet, are combined with gold, the result is reminiscent of Oriental palettes. Terra-cotta reds go well with russets, ochres, greens, and even blues. In this palette, which is similar to the palette of many Egyptian frescoes, the blue provides an oasis of cool color that juxtaposes pleasantly against the warm earthy colors.

Red is a good color for rooms intended for socializing—it evokes excitement and is conducive to conversation.

Seasonal Reds in the Garden

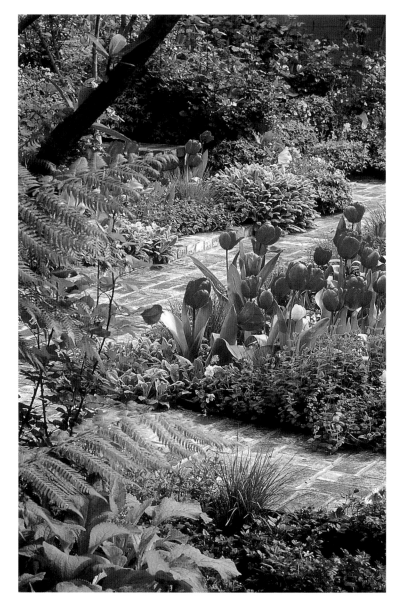

RED-HOT POKER, scarlet comet, fireglow, crimson flag, red rocket, and shooting star— even the names of red flowers capture our attention. Just as a woman in a red dress is seldom overlooked, red flowers in the garden rarely escape our notice. They exude excitement and flamboyance. Red flowers are conspicuous and make a strong statement in any garden, behaving as red does everywhere else—jumping out at us. Because of red's extroverted behavior, it is important for

Red flowers make a strong statement in any garden, especially when surrounded by red's complementary color, green.

Rambling heirloom roses are traditional flowers of romance.

gardeners to use this color in moderation so as not to create a visually exhausting environment. In general, a lot of red is not a good idea in very small gardens, where it can look too intense; however, in larger gardens red creates interest and visual intrigue.

When planning a red flower garden, there are two important rules to keep in mind. First, there are two types of red: warm red and cool red. For example, a well-known warm red flower is the red poppy, often described as scarlet; whereas a 'Stargazer' lily has a cool red center that leans slightly toward blue. Second, beware of mixing cool red and warm red flowers together—they rarely look good together because each

Nemesia strumosa adds a riot of red to any garden.

type of red belongs to its own "temperature family," and each has its own rules regarding color combinations.

Cool reds (also called blue-reds) such as crimson, magenta, and cerise harmonize well with purple because they both share blue as a common pigment. Also, the deeper shades of purple temper the exuberance

of these blue-reds. For spring, plant the rich crimson wallflower 'Vulcan' in drifts with deep purple tulips such as 'Negrita' interspersed. In the summer, make a dramatic statement with the 'Miller's Crimson' cultivar of primula combined with bugle. And for a late summer finale of cool red, plant the 'Red Rocket' variety

COMBINATIONS
FOR
WARM REDS

Spring
Tulip
(*Tulipa greigii* 'Red Riding Hood') or other red tulips

Bells-of-Ireland
(*Moluccella laevis*)

Early to Midsummer
Red Poppy
(*Papaver orientale*)

Midsummer to Fall
Salvia
(*Salvia coccinea* 'Lady in Red')

of snapdragons with violet-blue larkspurs.

The fiery glow of warm red flowers stands out best against bright green—red's opposite and complementary color. In both his paintings and gardens, the impressionist painter Claude Monet relied on the dramatic juxtaposition of complementaries to create a dynamic visual effect. He knew that warm red flowers appear to jump out from green foliage, and exploited this phenomenon in his paintings of red poppies in green fields. The dynamic visual effect of red jumping

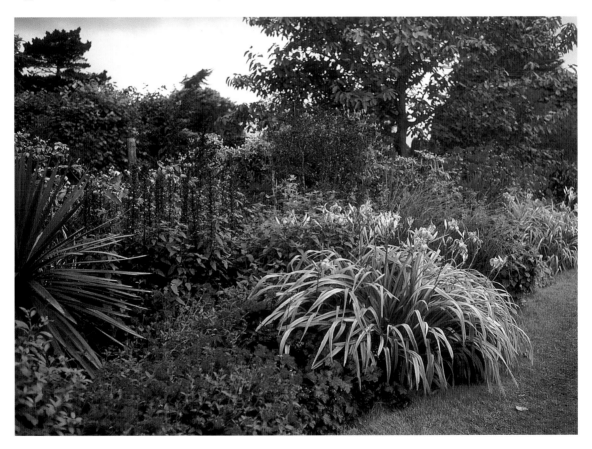

This reddish foliage, as well as the red flowers, contributes to a garden's intrigue.

out from green is also noticeable in photographs; however, it is most dramatic outdoors.

There are several warm red tulip varieties, such as 'Red Riding Hood,' 'Red Dawn,' and 'Red Emperor' that bloom in spring. Planted as a border in front of a row of Bells-of-Ireland, the red tulips will appear to float on a sea of glowing green. In early to midsummer, the red poppies bloom. Their large scarlet blossoms are one of the most recognized reds in the flower kingdom. Although the poppy starts out with plenty of its own foliage as an ample stage for its symphony in red, later in the year its foliage grows ragged. To plan for this, plant poppies at the back of a garden or the edge of a naturalized meadow where the wear and tear of their later foliage won't be as noticeable. From early summer to fall, the 'Lady in Red' cultivar of salvia produces vibrant scarlet blooms that hummingbirds and butterflies

RED ROSES
BY TYPE

Shrub Roses

Rosa 'Scarlet Knight'

Rosa 'Scarlet Meidiland'

Rosa 'Sarabande'

Rosa 'Tuscany Superb'

Rosa 'Mister Lincoln'

Rosa 'Red Devil'

Rosa 'Red Masterpiece'

Rosa 'My Valentine'

Climbing Roses

Rosa 'Multiflora'

Rosa 'Paul's Scarlet Climber'

Rosa 'Don Juan'

Rosa 'Blaze'

Rosa 'Climbing Crimson Glory'

find irresistible. Because the brilliant red flowers sit on top of stems nearly two feet high, the salvia should be planted in front of green hedges or at the back of a garden that borders the landscape. Either of these locations will provide the green stage required for the effect of complementary contrast.

Note: Hardiness and blooming times vary according to zone (a geographic area based on minimum winter temperatures), and even local conditions. Check with a nursery or garden club to verify blooming times and to determine which flowers will survive and thrive in your area.

ROSES ARE RED

The red rose has long been prized by poets, lovers, and artists as a symbol of love, beauty, and perfection. Considered "the Queen of Flowers" because of its color, fragrance, and form, many varieties of the red rose have been in

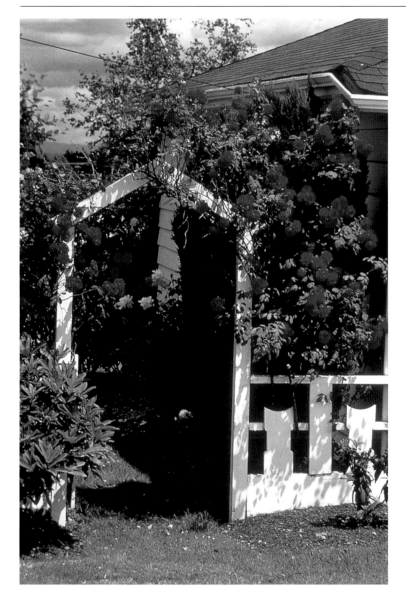

cultivation for thousands of years. In mythology, the red rose was dedicated to Venus, goddess of love and beauty, and was featured at festivals in her honor. The genus *Rosa* contains about 150 species, which grow in the wild and from which all other roses are descended. There are several different types of roses—species and shrub, old garden, hybrid tea, grandiflora, climbers and ramblers, and miniatures—and these are often divided into two broad categories: shrub roses and climbing roses. Red roses represent one of the finest red palettes in the flower kingdom.

Climbing red roses create a dramatic entrance to a garden.

The Rhythm of Red Music

*I*n RUSSIA, the bright, joyous sound of sleigh bells is described as "raspberry jingling." The Swiss composer Joachim Raff believed the sound of the trumpet to be scarlet, and others have claimed that clarinets, cornets, and trombones also fall into the category of instruments that "sound" red. Just as red is associated with energy, exuberance, and passion in the visual arts, it also represents such qualities in music. Therefore, instruments with lively, radiant sounds have often been described as red. Even musical keys can have colors; the Russian composer Rimsky-Korsakov once stated that the key of F-sharp was "decidedly strawberry red."

Many philosophers, musicians, and artists have sought

In this painting, both sensuality and energy are associated with music through the use of color.

correspondences between the color red and specific musical notes, as well as musical timbres and feelings. Aristotle speculated that the most attractive colors, such as red, depend on the mixture of black and white in simple or regular ratios, similar to the harmonious relationships between certain notes of the musical scale. Even as late as the sixteenth century, the ancient Greek theory that all colors exist on a linear scale between black and white still held sway. Red was considered by some to be one of the "simple" colors, which had a regular mathematical relationship in its component mixture between black and white.

Around 1670, Sir Isaac Newton used prisms to analyze the color spectrum. Newton at first recognized eleven colors in the rainbow, but later reduced the number of colors to seven, corresponding to the

seven notes of the diatonic scale. Newton wrote, "May not the harmony and discord of colors arise from the proportions of the vibrations propagated through the fibers of the optic nerve into the

Suggestions for Red Listening

If you want to experience the fire, passion, and energy of red in music, you might want to check out the classical pieces "Mars, the Bringer of War" from Holst's tone poem *The Planets*, or "Red" from *A Colour Symphony* by Bliss. Beethoven has been described as having "red" energy. Or you could try Larry Clinton and his Orchestra's "A Study in Red." For red rock, try King Crimson's intense "Red," Peter Gabriel's "Red Rain," or Laurie Anderson's "Beautiful Red Dress."

brain, as the harmony and discord of sounds arise from the proportions and vibrations of the air?" In Newton's scale, red corresponded to the note C. About fifty years later, the French Jesuit Louis-Bernard Castel assigned the color red to the note G in his design for a color organ that used translucent color strips illuminated by lanterns and candles to flash colors along with musical notes. A. Wallace Rimmington, another color organ creator, developed a color organ in the early 1890s. Rimmington ascribed the note C to deep red, and the note C-sharp to crimson. The Australian Alexander Hector performed along with music on a color instrument made from X-ray tubes and incandescent lamps,

Jazz has two flavors: hot and cool. From the use of the color red in this painting, we can "hear" the hot jazz coming from the band.

among other things. Hector's scale used the note A for red. In the mid-1800s, George Field, a British color theorist who sought connections between colors, music, and other arts, assigned red to the note E.

In the early twentieth century, the Russian composer and mystic Aleksandr Scriabin was influenced by the teachings of a nineteenth-century mystical school called theosophy, which attributed to red the quality of "sensuality." Scriabin was closely associated with the efforts to relate color to music and was one of the rare people to experience "synesthesia," in which the subject "hears" colors. Scriabin "heard" the color red as corresponding to the note C, corresponding to the concept of "human will."

By the late nineteenth century, most theorists had abandoned the attempt to relate colors to specific notes, and

instead sought correspondences with subjective psychological states or moods. "Red: The Colour of Rubies, Wine, Revelry, Furnaces, Courage, and Magic" was one of the movements of *A Colour Symphony* by British composer Arthur Bliss, that sought to give a musical interpretation of the heraldic primary colors. The Russian abstract expressionist painter Wassily Kandinsky spoke of the "inner sound" of red, likening it to the sound of a trumpet, "strong, harsh, and ringing." Kandinsky felt that a cool, light red "contains a very distinct bodily or material element, but it is always pure, like the fresh beauty of a young girl's face. The ringing notes of a violin exactly express this in music."

Musical Revolt in Red Sneakers

"You say you want a revolution, well, you know, we all want to change the world," wrote Paul McCartney and John Lennon in 1968. Thirteen years later, in Boston, a group of young composers founded the collective "Composers in Red Sneakers" to launch their own musical revolution against the relatively closed world of commissioned works for established ensembles. The classical music establishment tends to adhere rigidly to the tradition of academia, and the "new music" movement is often equally inaccessible and pretentious due to the difficult and abstract nature of most new compositions. Through engaging and informal approaches, the Red Sneakers presented new music that crossed many of the bounds of classical "correctness." For a time, the group was so popular that they had to turn audiences away from their concerts. By establishing a policy of free admission for audience members wearing red sneakers, the group increased the festive and unconventional character of their performances. The Composers in Red Sneakers claim to have chosen their name as a reflection of their informality, as well as to draw attention to themselves. However, the "red sneakers" speak for themselves, perfectly betraying the rebellious and spirited natures of these iconoclastic composers.

Wearing Red

*A*s a fashion color, red's popularity blinks on and off like a stoplight. In 1910, after a period of muted Edwardian colors, the French couturier Paul Poiret introduced bold, vibrant hues into the world of fashion, including many brilliant reds. Poiret did not reserve the color red for accents, as had been the trend previously, but instead used it for entire outfits. From the twenties through the fifties, Parisian designer Coco Chanel established flame red as an important part of her basic fashion palette, and in the thirties Elsa Schiaparelli introduced a new blend of magenta and pink called "Shocking Pink." Later, in the seventies, fashion editor Diana Vreeland came to be considered another aficionada of red. In her auto-biography, Vreeland passionately asserts that red "makes all the other colors beautiful." However, if Vreeland was the "Queen of Red," the "King of Red" is Roman couturier Valentino, whose "Valentino red" is extensively recognized in the world of fashion. Valentino may have expressed a sentiment felt by all of these designers when, on his thirtieth anniversary in fashion, he declared, "Red is the color of happiness."

The effects of the color red are no less apparent in fashion than they are in any other realm. Red stimulates the senses and commands attention, so unless red is worn in a poppy field, it is certain to be noticed. Psychologically, red is conducive to vigor and excitement; therefore, some people suggest that red clothing may be an antidote to passivity. Symbolically, red clothing is about assurance, strength, and power. A recent magazine poll supported the myth of women's red power suits; a surveyed sample of top U.S. business-women revealed that 80 percent frequently wear red outfits to work. This statistic doesn't suggest a recent trend; people have been wearing red to enhance their status and power throughout history. The crimson

Because red is such a dramatic accent color, red scarves have been popular in many different periods of history.

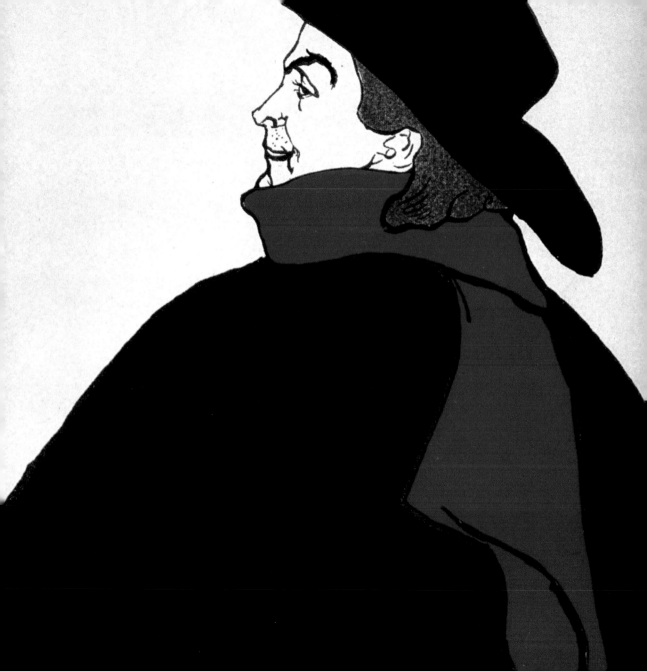

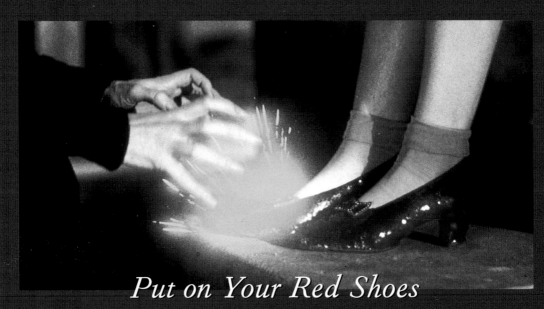

Put on Your Red Shoes

"When I gain those ruby slippers, my power will be the greatest in Oz!" Things didn't turn out quite the way the Wicked Witch of the West envisioned; she received a painful shock when she tried to remove the slippers from Dorothy's feet. This scene from *The Wizard of Oz* is just one testament to the power—and potential danger—of red shoes. In the famous fairy tale and movie of the same name, red shoes dance the wearer to death. In Elvis Costello's song "(The Angels Wanna Wear My) Red Shoes," the strength needed to recover from a failed romance is represented by red shoes so powerful that even the angels want to wear them. As history has shown, power and danger go hand in hand, and red shoes are no exception to this rule. Nonetheless, next time you pack for a journey, consider the advice in Tom Waits' song "Red Shoes by the Drugstore": "Bring a raincoat, bring a suitcase, bring your dark eyes, and wear those red shoes." With feet clad in scarlet, you have to be prepared, for anything could happen.

robes of British royalty, the scarlet ecclesiastical robes of the Catholic Church, and the uniforms of various military officials are familiar examples of red worn as a badge of power and authority. Even more common but less overtly recognized as symbols of power are red lipstick and nail varnish. Cosmetics are usually worn to enhance physical attractiveness, which in cultures that place great importance on beauty has the effect of also enhancing one's power. In the ancient Babylonian creation myth, for example, Marduk, god of Babylon, smeared red ochre on his lips before doing battle with a powerful serpent. He won the battle, and from the corpse of the serpent he created heaven and Earth. Without the red lipstick, who knows how the story might have ended.

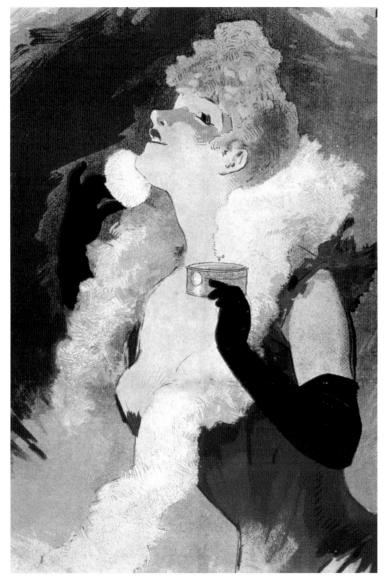

Detail of poster advertising Sarah Bernhardt's rice powder cosmetic.

The Four
Seasons of Red

Because red is such a dominant color—both symbolically and visually —many people shy away from wearing it. Yet, there are many occasions for which red clothing is appropriate, providing the right tints and shades of red are worn. In 1942, Susan Caygill, founder of the Academy of Color, developed a concept of personal color harmony that correlates individual coloration with seasonal color palettes. Caygill was inspired by the color theories of Bauhaus artist Johannes Itten, who believed that all individuals have an innate color harmony that can be used to complement and enhance their lives. Caygill developed parameters for determining personal palettes of color that enhance and even improve

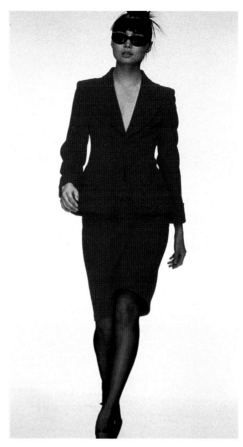

Red clothing can be an antidote to passivity.

one's appearance. The personal palettes are determined through color analysis, which examines hair, eye, and skin coloring. After analyzing these

physical factors, a color analyst assigns each individual a "color-based" season: winter, spring, summer, or autumn.

According to color analysts, each season has a palette of reds that are in harmony with particular skin tones. Winter people can wear strong, vibrant reds, such as primary red, Christmas red, cranberry, burgundy, and charcoal red. Winters can also wear all of the "berry" reds— raspberry, blackberry, cherry, fuschia, magenta, and blue-pinks. The summer palette, in contrast, includes pink reds, rosy reds, soft cherry and cranberry, muted burgundy, quiet raspberry, and watermelon. Autumn's colors include orange-reds, tomato red, paprika red, and brick red. Spring people look great in clear and yellow reds, salmon red, coral red, apricot red, and a soft, rusty red.

THE FOUR SEASONS OF RED
What Season Are You?

SPRING

Skin
Gold undertone. Pale and/or ivory skin. Peach or rosy cheeks. May tan and blush easily.

Hair
Yellow blond, strawberry blond, honey blond, auburn, red. Later: golden gray.

Eyes
Bright blue to dark blue, green-blue, gold-green, amber, golden brown, topaz. Yellow-gold flecks.

SUMMER

Skin
Blue undertone (sometimes pink). Fair and/or pale skin. Medium to dark brown freckles.

Hair
Blond as children. May be light brown as adult, ash overtones. Later: blue-gray or silver.

Eyes
Blue, aqua, gray, green, hazel, soft brown. May be cloudy or have white flecks.

FALL

Skin
Gold undertone. Ivory, peach, or golden-beige skin. May be sallow or ruddy. Golden freckles.

Hair
Honey blond, auburn, strawberry blond, brown with red or gold highlights, most true redheads. Later: copper or warm gray.

Eyes
Brown, amber, hazel, green, turquoise. May have golden flecks.

WINTER

Skin
Blue undertone. White to rose or beige to dark olive skin, and most Black and Asian skin. Some freckles.

Hair
Mostly dark: medium to dark brown, and black. May have red highlights. Later: silver or gray.

Eyes
Light to dark brown, dark gray, blue, green, gray-green. May have white flecks.

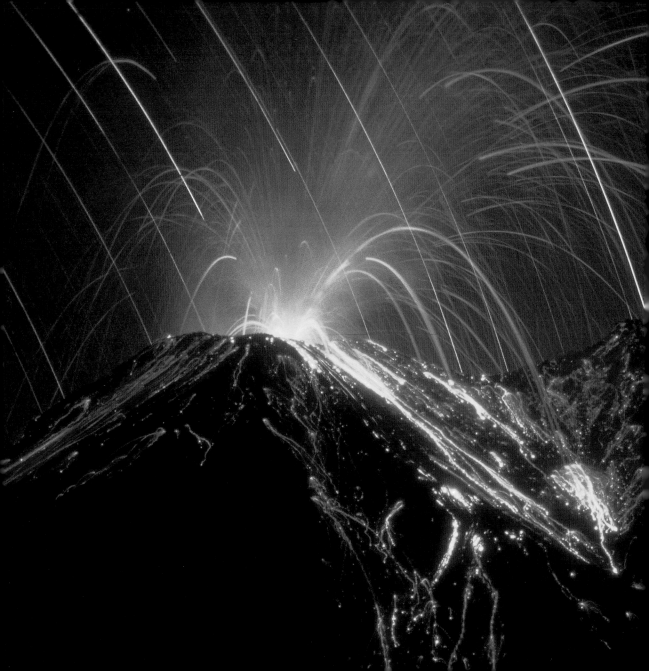

This volcano in Costa Rica is proof
that Earth's planetary heart is beating.

DISCOVERING RED

Elemental Red

THE RED EARTH

THE EARTH YIELDS RED IN ITS SOIL, SAND, clay, rocks, and stones. When any of these materials are colored red, it is always the result of red minerals. The most dramatic examples of red in the world of minerals are the gemstones. In order for gemstones to form far below the surface of the Earth, a process not unlike those claimed by the alchemists must occur. Hot, lava-like magma cools and slowly solidifies into rock. Sometimes, if the magma cools especially slowly, nature mixes an "elixir" of color and light to

75

create the rare and precious minerals we call gems. The conditions required for the formation of gems vary from one type of gem to another, but all require various degrees of intense heat, pressure, cooling, solidifying, and perfect timing. The precise combination of forces and timing occurs very rarely, and even when it does occur, the gems are still beyond our reach. Only when internal pressures force the surrounding rock to the Earth's surface, where it is eroded by weather, are the gems exposed.

The mineral world has an alluring assortment of red gemstones that have been admired and valued throughout history. According to a tradition of monthly birthstones dating back to the sixteenth century, January belongs to the garnet and July to the quintessential red gem, the ruby. The word "ruby" comes from the Latin *rubrum*, which means "red," and "ruby" has become part of our color vocabulary. Yet "ruby red" is no ordinary red; it's a rich, magical red. Just as

The ruby is the ruler of colored stones—often worth more than a diamond of equal size.

the color red crowns the seven colors of the rainbow, the ruby is the ruler of colored stones. The Bible identifies the ruby as the "Lord of Gems," and the Sanskrit name for the ruby translates as "King of Precious Stones." Hindu lore claims that rubies submerged in water would cause the water to boil, because an inextinguishable fire is trapped within the glowing stone. Throughout history, many different cultures have believed the ruby to be an amulet of protection against evil and disease, an antidote to poison, and a promise for health and happiness. In *The Wizard of Oz* Dorothy's sparkling ruby slippers provided the promise and protection traditionally associated with real rubies. While she traveled in Oz, Dorothy's ruby slippers protected her from the Wicked Witch of the West. When all other methods failed to return Dorothy to her home, the slippers carried her there after three magic clicks of her heels.

Because of its rarity, the ruby has always been considered a very valuable gem. A fine ruby can cost more than a diamond of equal size. Marco Polo reported that the king of Ceylon had an especially large and magnificent ruby for which Kublai Khan offered an entire city, but the king would

not part with it. The best source—in fact, one of the only sources—for truly fine rubies is the Mogok area of Upper Burma. Although it is not known exactly how long this area has been mined for rubies, implements dating as far back as the Stone and Bronze ages have been found there. This region was renowned in legend as being dangerous and unhealthy, so the risk of obtaining rubies was great, thus increasing their value. The legend of Sinbad the Sailor refers to a treacherous valley of precious stones, which is believed to be the Mogok region. However, all that sparkles red is not necessarily ruby. The famous "Black Prince's Ruby," set in the front of Britain's Imperial State

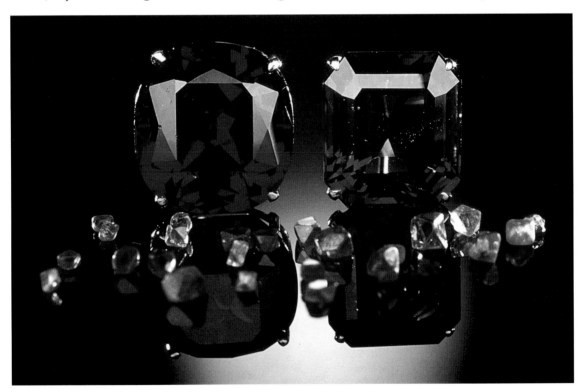

Spinels are sometimes mistakenly identified as rubies. The famous "Black Prince's Ruby" set in the front of Britain's Imperial State Crown is actually a spinel.

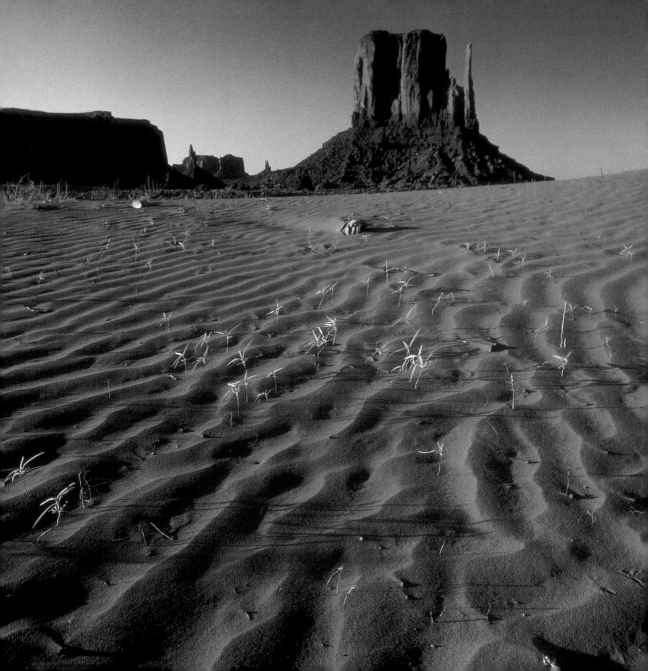

Crown, is not a ruby at all, but a spinel. Although spinels are sometimes called the "mother of ruby" and have been found in a beautiful range of reds—blood red, rose red, and carmine red—they do not enjoy the recognition and lore that rubies do.

Red garnets come in two main varieties: pyrope and almandite. Pyrope garnet was taken from the Greek word *pyropos,* meaning fiery. Almandite garnet is described as "aurora red" and tends to be more of an orange-red. In the Old World, garnets were believed to ward off accidents during travel. In the New World, Native American shamans searched the desert sands for pyrope garnets to use in their medicine rattles because the hardness of the garnets made

North America's southwestern desert has a characteristic reddish color, evoking the intense heat of the climate.

them last longer than other available materials. In the American Southwest, garnets were sometimes referred to as "anthill garnets" because they were frequently discovered on the sides of anthills, having been pushed there by tunnel-digging ants.

Red tourmaline, also called rubellite, varies from pink to nearly ruby red. Red quartz, called chalcedony or carnelian, is a translucent red color that was highly prized by the Greeks and Romans, who used this relatively soft stone in carved signets and rings. Another name for the stone is cornelian, which is from the Latin *cornus,* a type of tree with red berries. There is even a red variety of Mexican opal sometimes called a cherry opal. Among the red gems, no stone, not even the ruby, is as rare and valuable as the nearly nonexistent red diamond. And lastly, at the not-so-brilliant end of the red mineral spectrum is the red clay from which so many

of our structures, vessels, jewelry, and instruments have been made.

RED WATER AND RED SNOW

Separating the Arabian Peninsula from northeastern Africa is the only body of water permanently described as red—the Red Sea. The Red Sea's name is derived from the reddish color of its waters, which is caused by a proliferation of red algae. This microscopic organism also creates the "red tides" that periodically occur in other seas. In the well-known biblical story, Moses was leading the Israelites out of Egypt when God parted the Red Sea to let them pass, and then closed it behind them to drown the pursuing Egyptians. The Red Sea thus became a symbol of salvation for the Hebrew peoples.

Unusual as red water is, red makes yet another appearance in the element of water—

as red snow. In the Alps, as well as in other arctic and alpine regions, minute algae called *Protococcus nivalis* can turn snow red. The algae make the snow look like it is sprinkled with red gemstones. As beautiful as this sight may be, however, some people regard red snow as an omen of evil.

SUNSETS AND SUNRISES

When the sun is directly above us, its light has a relatively short distance to travel through Earth's atmosphere before reaching our eyes. As the sun descends toward the horizon, however, its light has to travel longer distances to reach our eyes. The lengthened path of the sun's rays results in a scattering of light that creates the often admired and romanticized red color of the setting sun. During the day, the particles in the atmosphere "scatter" or reflect mostly blue light. As the sun sets, the color of the scattered light changes

with the lengthening of the light rays, first to yellow, then to orange, and finally to the fiery red of the setting sun. At sunrise, the sequence is reversed: the sky starts out with the "rosy fingers of dawn" and gradually changes toward orange and yellow until finally the sun is up and the sky is blue.

RED PLANETS

Named after the Roman god of war, Mars is the fourth planet from the Sun in our solar system. Its predominantly red color—evocative of war, anger, and courage—established the symbolic association between the planet and the god. Mars is home to the largest volcano in

The lengthened path of the sun's rays results in a scattering of light that creates the often-romanticized red color of the setting sun.

our solar system, Olympus Mons. Seventeen miles high— three times higher than Mount Everest—and covering an area nearly the size of Arizona, Olympus Mons at one time

spewed its fiery magma across the surface of the Red Planet.

In his book *Pale Blue Dot*, astronomer Carl Sagan hypothesizes about the skies of planets other than Earth. In 1976, color photographs radioed to Earth by the *Viking 1* spacecraft that landed on the surface of Mars showed the sky of the Red Planet to be a pinkish

ochre color that some would describe as salmon. Another red planet, at least from the perspective of someone standing on its surface, might be Venus. Sagan speculates that because the atmosphere of Venus is ninety times thicker than the Earth's, it probably bounces most of the wavelengths from the blue end of the spectrum back into space, letting only the longer wavelengths reach the surface. This would result in a red sky, probably not unlike that of a sunset on Earth.

RED STARS

Our Sun is an average-sized star that is still in its hydrogen-burning stage, which is characterized by white or yellowish white light. As a star depletes its supply of hydrogen, it then burns heavier elements such as helium in its nuclear furnace. This change causes the star to grow in size and brightness and to give off most of its light in

the red range of the spectrum. A star in this phase is called a "red giant." According to current predictions, our Sun won't evolve into a red giant for several billion years.

The Red Shift of the Expanding Universe

When astronomers noticed that galaxies and quasars were leaving a trail of red light as they moved, they realized that they had discovered something really big—a potential sign of the original "big bang" from which the universe is believed to have formed. When the frequency and, therefore, color of light changes from the blue end of the spectrum to the red, it is an indication that the light source, in this case galaxies and quasars, is moving away from the observer. As the light source recedes from the observer, the frequency of the light appears to lengthen or "shift" towards the longer, red end of the light spectrum, which is why scientists call this phenomenon the "red shift." The red shift lends credence to the "big bang" theory of creation by providing concrete evidence of the primeval explosion that sent matter flying outward at extraordinary rates. Astronomers also measure the red shift of light from distant galaxies and quasars in an attempt to determine the age of the universe.

Red Pyrotechnics

Fire is the element to which we attach the most widespread symbolic associations and which we have harnessed in the most diverse ways, from the flames that have warmed us and cooked our food to the agonizing wounds resulting from the harnessing of fire as a weapon. However, long before fire was utilized for weaponry, it was used to create beautiful displays of light against the backdrop of the night sky. The formal name for these fireworks—pyrotechnics— means "fire art." Most fireworks displays are created by starting powder that ignites and sets off bursting powder, which in turn ignites the metallic salts that give fireworks their spectacular colors. Red fireworks are created by calcium, whereas strontium burns a deeper crimson color. Just as we use elements such as calcium and strontium to color fire, scientists can examine the color of flames to identify what elements they contain.

Fire on the Mountain: The Volcano

Volcanoes are proof that a planetary "heart" is beating. A planet without volcanic activity is a cold planet that, as far as planets go, is dead. The molten lava that oozes out of volcanoes and cracks in the ocean floor is analogous to the blood that flows through our veins.

But volcanoes are as life threatening as they are life

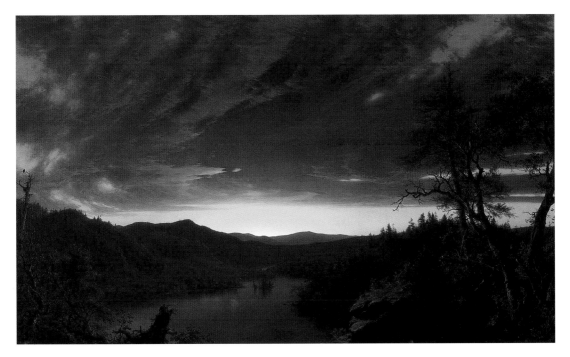

As the sun sets, the color of the scattered light changes—first to yellow, then to orange, and finally to fiery red.

giving. The fiery magma that erupts with such force from the bowels of the Earth can scar landscapes and obliterate populations. Named after Vulcan, the Roman god of fire, most of the world's active or formerly active volcanoes are situated in what is called the great "Ring of Fire." This arc of volcanoes reaches from the western edge of North America down past South America and over toward the Pacific Basin. Some of the most powerful eruptions are called Pelean eruptions, named after the 1902 eruption of Mount Pelee on the Caribbean island of Martinique. During this eruption, the nearly incandescent red magma spewed out of the volcano in powerful blasts. The most violent blasts, however, occur when red-hot molten rock strikes surface water, groundwater, or ice on its way up from the Earth's core.

The Living Kingdoms of Red

RED PLANTS

Nature has created a diverse distribution of red in the plant kingdom—in flowers, leaves, fruits, and seeds. Although red is not rare in the botanical world, it is nonetheless striking and often startlingly beautiful. To stumble upon the glowing red flowers of trumpet honeysuckle while walking along a stream in a shaded wood, to reflect on the historical talismanic use of the poisonous red berries of deadly nightshade, and to watch the carnivorous scarlet-colored mouths of the Venus flytrap snap shut on an unsuspecting insect are just a few of the many red experiences possible in the plant kingdom.

Red flowers, with their variety of red hues and assortment of shapes, are one of nature's most captivating uses of the color red. The Maltese cross was named after the arrangement of its scarlet petals that create a shape similar to that of the cross carried by the knights of Malta. It was originally introduced from Asia but can now be found growing wild in open woods and along roadsides in the northeastern United States and southeastern Canada.

Named after the bright red robes worn by Roman Catholic cardinals, cardinal flower is considered one of the most vibrant examples of red in the flower kingdom. It is pollinated primarily by hummingbirds because most insects struggle with its slender, tubular flowers. Other red flowers favored by hummingbirds include bee balm, with its moplike head of brilliant crimson flowers, and trumpet honeysuckle, an elegant climbing vine with bright red trumpet-shaped flowers.

The crimson pitcher plant is a carnivorous plant with drooping blood-red flowers and pitcher-shaped leaves. The "pitchers," which are white with veins of violet red, secrete a nectar that accumulates into a sticky pool from which unsuspecting insects usually cannot escape.

Not all noteworthy appearances of red in the plant kingdom are limited to flowers. Belonging to the snapdragon family is the Indian paintbrush with its scarlet-tipped leaves that look as if they were dipped in paint. The Venus flytrap,

The scarlet-tipped leaves of the Indian paintbrush look as if they were dipped in red paint.

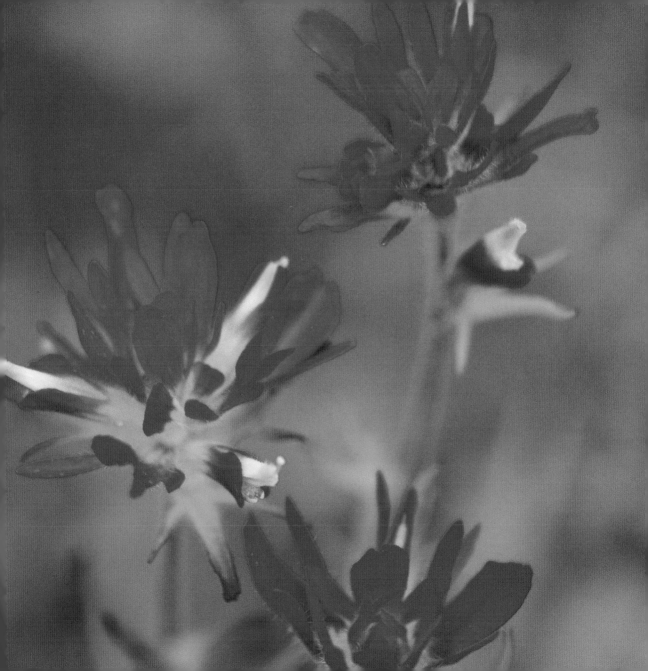

best known for its ability to trap and digest insects and other small animals, grows red "mouths." Surrounding the base of the Venus flytrap's slender stalk are hinged green leaves shaped like clam shells. The leaves have spikes along their edges that act as interlocking "fingers" when the traps snap shut on unlucky intruders. The glands on the inside of the leaves secrete a bright scarlet sap that colors the interiors of the traps, making them more attractive to insects.

Of all the red leaves that nature has to offer, few are likely to be as beautiful as the tree leaves of autumn. In the late summer as the growing season slows down, trees, which had previously provided

Few reds are as beautiful or fleeting as the bright maple leaves of autumn.

nourishment for their leaves, develop a barrier of cells at the base of their leafstalks. These

Quince blossoms breaking through the melting snow create a striking contrast of red against white.

cells inhibit the flow of nutrients, and the leaves stop producing the chlorophyll responsible for their green color. Without the chlorophyll, the other pigments in the leaves slowly become visible. Most trees contain

yellow pigments, which account for the profusion of yellow and gold foliage. Fewer trees, however, contain the red pigment responsible for the scarlet, crimson, and violet red colors. When the trees with red pigment, such as sumacs, sugar maples, and oak, are exposed to sunlight after the production of chlorophyll has ceased, they burst into spectacular displays of red, signaling the end of summer.

One of the shapes that nature seems to prefer to color red is that of the berry. There are bunchberries, bearberries, partridgeberries, elderberries, baneberries, cranberries, raspberries, strawberries, and winterberries. Not to be forgotten are deadly nightshade's poisonous bright-red berries that were once used in England as an amulet against witchcraft.

RED ANIMALS

Nearly every class of animal can claim a few red members; however, nature was especially generous in its distribution of red to birds. Many of the most captivating reds belong to the avian world, where the most brilliant hues are often related to courtship. An unusual example of the color red in courtship ritual is the male frigate bird, a large seabird found on coasts in tropical and semitropical areas. What makes the frigate bird's red so unique is that it is entirely unrelated to feathers. The male frigate has a featherless, crimson-colored sac that he inflates until he has a huge red balloon protruding from his chest. This unique feature serves a dual purpose— to attract and arouse a female and to warn other males away from his nest. The male frigate

Many groupers, including this spotted grouper from the Red Sea, turn deep red just before lunging at their prey.

There's more than one way to get a date—the male frigate bird relies on his inflatable crimson-colored sac.

keeps his display inflated until the female lays her first egg. The frigate bird is also known as the man-of-war bird because it feeds by forcing other birds to drop their food while in flight, which the frigate bird then catches in midair.

The scarlet ibis is an exceptionally bright red wading bird found along the coast of northeastern South America. It uses its long, hooked bill to search for frogs, insects, shellfish, and small fish. Both sexes of the scarlet ibis are brightly colored, unlike many other bird species such as the northern cardinal. The bright red color of the northern cardinal, also known as the redbird, belongs only to the male of the species. The cardinal is a non-migratory woodland bird found over much of the central and eastern United States and Mexico. Because the cardinal does not migrate, it makes a spectacular statement of color against the snowy landscape of winter. Both male and female cardinals are known for their musical singing and pointed head crests. Also known for its song is the scarlet tanager, which is more likely to be heard than seen because of its preference for foliage growing in the upper branches of trees. The scarlet tanager has a lipstick-red body and black wings, a color pattern repeated in the vermilion flycatcher of Central and South America. For both of these species, the brilliant red coloring belongs only to the males.

Audubon called humming-birds "lovely fragments of the rainbow." The jewel-like iridescent coloring of these tiny birds is accentuated by their high-speed flight. Hovering like miniature whirring

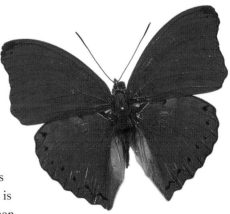

This red *Cymothoe rheinoldi* butterfly is native to Africa.

helicopters, they can fly up, down, sideways, and in circles. Wearing a glossy red chest is the crimson topaz of the rainforests of northeastern South America. Although the ruby-throated hummingbird is the best known of the hummingbirds with ruby-colored

and the rufous hummingbird, both of which live in the western United States; and the calliope hummingbird, which is the smallest hummingbird in North America, measuring only three inches in length.

When it comes to spectacular coloring, mammals often

crowd by virtue of their red coloring. South America is home to several red primates, including the rare red uakari that lives high in the trees in forests along the Amazon River. The uakari has a reddish coat; however, it is his furless face that is most striking—perpetually colored the deep crimson of an embarrassed blush. Red howler monkeys are another red arboreal primate of the South American rain forests. The males create an early-morning chorus of booming howls, a sound for which they are named. Far from South America, in the jungles of Borneo and Sumatra live the rusty-red orangutans, whose name is the Malayan word for "man of the woods." Like most primates, these red apes spend much of their time in the trees.

Closer to the ground is a group of animals that often wear red as a banner of warning. The venomous eastern coral snake is a member of the

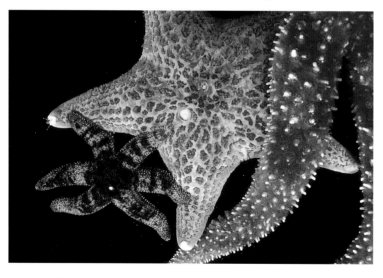

Marine invertebrates such as starfish are some of the most brightly colored creatures in the sea.

throats, there are several other species with similar patches of iridescent red feathers on their necks: Anna's hummingbird

lose out, tending to be mostly earth colors. However, there are a few red mammals that stand out from the fur-covered

cobra family and is found from North Carolina to northern Mexico; its venom can be fatal to humans. The eastern coral snake, with its bands of bright red, yellow, and black, engendered the rhyme "Red touching yellow, dangerous fellow." Because nature has employed the color red as a warning, some species have adopted red coloration to warn off predators, even though they lack poisons or other weapons to follow through on the threat. The harmless scarlet king snake and the mildly venomous false coral snake have both evolved coloration very similar to the coral snake, with whom they share the bright red and black bands but not the yellow.

Not all of the red in the animal kingdom is exterior coloration. Sometimes red,

infrared to be more precise, is in the eye of the beholder. Many snakes are believed to possess infrared vision, which means that they can see the

Sometimes nature uses red to enhance a feature, such as the brilliant red eye of this cock pheasant.

part of the spectrum on the other side of red, just outside the range of human vision. Seeing in infrared enables snakes to see the heat given off by the bodies of their prey, heat that would otherwise go undetected. Snakes, however, are not the only animals that can see infrared. The ferocious piranha may be famous for razor-sharp teeth that can strip

even large animals down to their bones in minutes, but their talent for seeing in the dark is no less remarkable. They have their environment to thank for their keen vision. The nutrient-rich waters of South American rivers appear black to us because molecules of decaying vegetation absorb almost all of the light that falls on the water, with the exception of the far-red light that borders on infrared. Over the course of evolution, the piranha's vision has adapted to this environment, and it can see in this far-red light. Given their furious appetites and feeding frenzies, it seems appropriate that the piranha swims through the murky river "seeing red."

**The red canna, painted by
artist Georgia O'Keeffe.**

THE
RED CURTAIN

T HE FOCAL POINT OF EVERY CHAIR IN THE theater is the red curtain that conceals the stage and creates an air of anticipation about the performance to come. The red curtain descends throughout the show as the theatrical work requires, breaking up the acts of plays, and signaling the conclusion of the performance. Just as in the death ritual of Shintoism, where a red cloth draped over a coffin prepares the departed for the afterlife, the closing of the red curtain signals the end of one performance and the start of another.

Art Credits

Frontispiece: Sandi Fellman. *My Sister Peggy*, Tokyo 1982

pg. 6-7: William Neill Photography. *Misty Red Roses*

pg. 8: Randy Wells/Tony Stone Images

pg. 9: Kobal Collection/Superstock Inc.

pg. 10-11: Gayle Ray/Superstock Inc.

pg. 12: Maciej Urbaniec. *Cyrk*, 1970. Offset lithograph, printed in color, 38½" x 26". The Museum of Modern Art, New York. Given anonymously. Photograph © 1995 The Museum of Modern Art, New York

pg. 13: Barbara Kruger. *"Untitled" (Are we having fun yet?)* 147½" x 103", photographic silkscreen/vinyl, 1987. Courtesy Mary Boone Gallery, New York

pg. 14-15: John Martin. *The Great Day of His Wrath*. Tate Gallery, London/Art Resource

pg. 16 : P. Van Rhijn/Superstock Inc.

pg. 17: © Matt Zumbo

pg. 19: J. L. David/Superstock Inc.

pg. 20: Donovan Reese/Tony Stone Images

pg. 21: *Book of the Dead*/Budge, 1895

pg. 23: Georgia O'Keeffe, © The Georgia O'Keeffe Foundation. *Nude Series, Red, Seated*, 1918. Watercolor on paper, 12" x 8⅞". Photo © 1987 by Malcolm Varon, NY

pg. 24-25: Thomas McKnight. *Atlas* (Mythologies Suite). Casein on canvas

pg. 26-27: *Tres Riches Heures*, Jean de Berry

pg. 28: William Holman Hunt (1827–1910). *The Two Gentlemen of Verona—Valentine Rescuing Sylvia from Proteus*. Oil on canvas. Used permission of Birmingham Museums and Art Gallery

pg. 30: Paul Gauguin, French, (1848–1903). *The Loss of Virginity*, 1890–91. Oil on canvas, 35½" x 51¼". The Chrysler Museum of Art, Norfolk, VA. Gift of Walter P. Chrysler, Jr.

pg. 31: Richard Edward Miller. *The Boudoir*, 1937. The Pennsylvania Academy of the Fine Arts, Philadelphia

pg. 33: John Everett Milais, (1829–1896). *Effie, The Artist's Daughter*.Superstock Inc.

pg. 34: © Reagan Louie. *"Study Diligently and Improve Yourself Daily"*—Children's Park, Hangzhou, 1987

pg. 35: Randy Wells/Tony Stone Images

pg. 36-37: Derek Boshier. *False Patriots*, 1984. Oil on canvas. Collection of the Modern Art Museum of Fort Worth

pg. 38: Museum of Art and Archaeology, University of Missouri—Columbia. Gift of Mr. and Mrs. Stanley Marcus

pg. 39: © Turner Entertainment Co., 1921. All Rights Reserved

pg. 40: "Coca-Cola" and the Santa design are registered trademarks of The Coca-Cola Company. Courtesy The Coca-Cola Company

pg. 42-43: Age Spain/Superstock Inc.

pg. 45: *Youth Sleeping Under a Willow Tree*, Iran, Safavid period, early 17th century. Opaque watercolor and gold on paper, H. 21.5 cm. © The Cleveland Museum of Art, 1995, Purchased from the J. H. Wade Fund, 44.494

pg. 46: Joseph Cornell. *A Pantry Ballet (for Jacques Offenbach)*, 1942. Wood, plastic, paper and metal, 10½" x 18⅛". The Nelson-Atkins Museum of Art, Kansas City, Missouri (Gift of the Friends of Art)

pg. 47: Vincent Van Gogh. *The Night Cafe*, 1888

pg. 48: Robert Motherwell, (1915–1992). *The Redness of Red*, 1985. Lithograph, 83/100. Lauren Rogers Museum of Art, Laurel, MS

pg. 51: Sandi Fellman. *Kintaro and Maple Leaves Tattoo*, 1984

pg. 52-53: © Dick Busher

pg. 54-55: *Wukoki Ruin, Wupatki National Monument, Arizona;* © Larry Lindahl

pg. 56-57: Keith Scott Morton Photographer

pg. 58: © Marion Brenner

pg. 59: © Rosalind Creasy

pg. 60: © Marion Brenner

pg. 61: © Rosalind Creasy

pg. 63: Courtesy Jackson & Perkins

pg. 64: Christian Pierre/Superstock Inc. *Stranger in Paradise*

pg. 66: William H. Johnson. *Jitterbugs V*, 1941–42. Oil on wood. Hampton University Museum, Hampton, Virginia

pg. 67: Eric Workman. Courtesy Converse, Inc.

pg. 69: Henri de Toulouse-Lautrec. *Aristede Bruant dans son Cabaret*, 1893

pg. 70: © 1939 Turner Entertainment Co. All Rights Reserved

pg. 72: Courtesy Donna Karan New York

pg. 74-75: Art Gingert/© Comstock Inc.

pg. 76: Courtesy of Tiffany & Co.

pg. 77: Courtesy Smithsonian Institution, Museum of American History

pg. 78: © Comstock Inc.

pg. 80-81: *Chimney Rock, Sedona, Arizona;* © Larry Lindahl

pg. 83: Frederic Edwin Church, American, (1826–1900). *Twilight in the Wilderness*, 1860. Oil on canvas, 101.6 x 162.6 cm. © The Cleveland Museum of Art, 1995. Mr. and Mrs. William H. Marlatt Fund, 65.233

pg. 85: P. Van Rhijn/Superstock Inc.

pg. 86: William Neill Photography. *Fallen Maple and Large-toothed Aspen Leaves on Moss, Acadia National Park, Maine*

pg. 87: William Neill Photography. *Melting Snow on Quince Blossoms, Merced River Canyon, California*

pg. 88: B. Apton/Superstock Inc.

pg. 89 (LOWER): Michael Burns and Ed Marquand. *Cymothoe rheinoldi (Africa)*

pg. 90: Sea Studios

pg. 91: G. I. Bernard, © Oxford Scientific Films/Animals Animals. *Eye of Cock Pheasant (Phasianus colchicus)*

pg. 92-93: Georgia O'Keeffe. *Red Cannas*, 1927

Bibliography

Ammer, Christine. *Seeing Red or Tickled Pink: Color Terms in Everyday Language.* New York: Penguin Books, 1992.

Apel, Willi, ed. *Harvard Dictionary of Music: Second Edition.* Cambridge, Mass.: Harvard University Press, The Belknap Press, 1972.

Arrowsmith, Nancy. *Field Guide to the Little People.* New York: Hill and Wang, 1977.

Bassano, Mary. *Healing with Music and Color.* York Beach, Maine: Samuel Weiser, Inc., 1992.

Berger, Ruth. *The Secret Is in the Rainbow.* York Beach, Maine: Samuel Weiser, Inc., 1986.

Berlin, Brent, and Paul Kay, eds. *Basic Color Terms.* Berkeley: University of California Press, 1991.

Birren, Faber. *The Story of Color.* Westport, Conn.: The Crimson Press, 1941.

———. *Color: A Survey in Words and Pictures.* Secaucus, N.J.: Citadel Press, 1963.

———. *Light, Color and Environment.* New York: Van Nostrand Reinhold Company, Inc., 1969.

———. *Color and Human Response.* New York: Van Nostrand Reinhold Company, Inc., 1978.

———. *Color Psychology and Color Therapy.* New York: Citadel Press, 1992.

Birren, Faber, ed. *A Grammar of Color.* New York: Van Nostrand Reinhold Company, Inc., 1969.

Bisgrove, Richard. *The Illustrated Gertrude Jekyll: Colour Schemes for the Flower Garden.* Boston: Little, Brown, and Co., 1988.

Caygill, Suzanne. *Color: The Essence of You.* Millbrae, Calif.: Celestial Arts, 1980.

Chevreul, M. E. *The Principles of Harmony and Contrast of Colors and Their Applications to the Arts.* West Chester, Pa.: Schiffer Publishing Ltd., 1987.

Downer, John. *Supersense: Perception in the Animal World.* New York: Henry Holt and Company, 1989.

Estes, Clarissa Pinkola. *Women Who Run with the Wolves.* New York: Ballantine Books, 1992.

Faulkner, Waldron. *Architecture and Color.* New York: Wiley-Interscience, 1972.

Fell, Derek. *The Impressionist Garden.* New York: Carol Southern Books, 1994.

Fowler, W. Warde. *The Roman Festivals of the Period of the Republic.* Port Washington, N.Y.: Kennikat Press, 1969.

Gage, John. *Color and Culture.* Boston: Bulfinch Press, 1993.

Gimbel, Theo. *The Color Therapy Workbook.* Rockport, Mass.: Element Inc., 1993.

Goethe, Johann Wolfgang von. *Theory of Colors.* Cambridge, Mass: The M.I.T. Press, 1994.

Hall, Manly P. *An Encyclopedic Outline of Masonic, Hermetic, Qabbalistic and Rosicrucian Symbolical Philosophy.* Los Angeles: The Philosophical Research Society, Inc., 1977.

Halse, Albert O. *The Use of Color in Interiors.* New York: McGraw-Hill Book Company, 1978.

Herwig, Modeste. *Colorful Gardens.* New York: Sterling Publishing Co., 1994.

Hobhouse, Penelope. *Color in Your Garden.* Boston: Little, Brown, and Co., 1985.

Hope, Augustine, and Margaret Walch. *The Color Compendium.* New York: Van Nostrand Reinhold, 1990.

Hubel, David H. *Eye, Brain, and Vision.* New York: Scientific American Library, 1995.

Jackson, Carole. *Color Me Beautiful.* Washington: Acropolis Books Ltd., revised edition 1984.

Jarman, Derek. *Chroma.* New York: The Overlook Press, 1995.

Jekyll, Gertrude. *The Illustrated Gertrude Jekyll: Colour Schemes for the Flower Garden.* Boston: Little, Brown, and Co., 1988.

Jobes, Gertrude. *Dictionary of Mythology, Folklore and Symbols.* New York: The Scarecrow Press, Inc., 1962.

Johnson, Carl. *Fire on the Mountain.* San Francisco: Chronicle Books, 1994.

Kanitkar, V. P. (Hemant). *Hinduism.* Cheltenham, England: Stanley Thornes & Hulton, 1989.

Kargere, Audrey. *Color and Personality.* York Beach, Maine: Samuel Weiser, Inc., 1979.

Lindsay, Kenneth C., and Peter Vergo, eds. *Kandinsky: Complete Writings on Art.* New York: Da Capo Press, 1994.

Luckiesh, Matthew. *Color and Colors.* New York: Van Nostrand Co. Inc., 1938.

Luscher, Max. *The Luscher Color Test.* Translated and edited by Ian Scott. New York: Washington Square Press, 1971.

Mercatante, Anthony S. *The Facts On File Encyclopedia of World Mythology and Legend.* New York: Facts On File, 1988.

Parker, Ann, and Avon Neal. *Molas: Folk Art of the Cuna Indians.* Barre, Mass.: Barre Publishing, 1977; distributed by Crown Publishers, Inc., New York.

Parker, Julia and Derek. *Parker's Complete Book of Dreams.* London: Dorling Kindersley, 1995.

Porter, Tom. *Architectural Color.* New York: Whitney Library of Design, 1982.

Portmann, Adolf, Christopher Rowe, Dominique Zahan, Ernst Benz, René Huyghe, and Toshihiko Izutsu. *Color Symbolism.* Dallas: Spring Publications, Inc., 1988.

Richter, Gisela M. A. *Attic Red-Figured Vases.* New Haven: Yale University Press, 1967.

Riley, Charles A., II. *Color Codes.* Hanover, N.H.: University Press of New England, 1995.

Robinson, George W. *Minerals.* New York: Simon & Schuster, 1994.

Sagan, Carl. *Pale Blue Dot.* New York: Random House, 1994.

Scullard, H. H. *Festivals and Ceremonies of the Roman Republic.* Ithaca, N.Y.: Cornell University Press, 1981.

Simon, Hilda. *The Splendor of Iridescence.* New York: Dodd Mead & Co., 1971.

Sloan, Annie, and Kate Gwynn. *Color in Decoration.* Boston: Little, Brown, and Company, 1990.

Sloane, Eric. *American Barns and Covered Bridges.* New York: Funk & Wagnalls, 1954.

Squire, David. *The Complete Guide to Using Color in Your Garden.* Emmaus, Pa.: Rodale Press, 1991.

Stuckenschmidt, H. H. *Twentieth-Century Music.* New York: World University Library, 1969.

Theroux, Alexander. *The Primary Colors.* New York: Henry Holt and Company, 1994.

Varley, Helen, ed. *Colour.* New York: Leon Amiel Publishers, 1980.

Vreeland, Diana. *D.V.* New York: Alfred A. Knopf, Inc., 1984.

Wangu, Madhu Bazaz. *Hinduism: World Religions.* New York: Facts On File, 1991.

Weisberger, Edward, ed. *The Spiritual In Art: Abstract Painting 1890–1985.* New York: Abbeville Press, 1986.

Westrup, J. A., and F. L. Harrison, eds. *The New College Encyclopedia of Music.* New York: W. W. Norton & Co., 1959, 1976.

Wilder, Louise Beebe. *Color in My Garden.* New York: Atlantic Monthly Press, 1990.

Willis, Roy, ed. *World Mythology.* New York: Henry Holt and Company, 1993.

Woodford, Susan. *An Introduction to Greek Art.* New York: Cornell University Press, 1986.

Yeats, W. B., ed. *Fairy & Folk Tales of the Irish Peasantry.* New York: Dover Publications, Inc., 1991.

Zajonc, Arthur. *Catching the Light.* New York: Oxford University Press, 1993.

Zipes, Jack, ed. *The Trials and Tribulations of Little Red Riding Hood.* New York: Routeledge, Inc., 1993.

Zuckerkandl, Victor. *Sound and Symbol.* Princeton: Princeton University Press, 1956.